Women & Men
Write About Self-Pleasuring

FIRST PERSON
SEXUAL

Joani Blank, Editor

Down There Press
San Francisco, California

First Person Sexual © 1996 by Joani Blank

We offer librarians an Alternative CIP prepared by Sanford Berman, Head Cataloger at Hennepin County Library, Edina, Minnesota.

Alternative Cataloging-in-Publication Data

```
Blank, Joani, 1937-
   First person sexual: women & men write about self-
pleasuring. San Francisco, CA: Down There Press,
copyright 1996.
   Ninety-five selections, by Carol Queen, Annie
Sprinkle, Roy Edroso, Will Keen, and others.
   Includes resource list, as well as material on the
use of such sex aids as dildos, vibrators, and in-
flatable dolls.
   1. Men—Sexuality—Personal narratives. 2. Women—
Sexuality—Personal narratives. 3. Masturbation—Per-
sonal narratives. 4. Sex aid use—Personal narratives.
5. Vibrator use—Personal narratives. 6. Dildo use—Per-
sonal narratives. 7. Erotic essays. I. Title. II.
Title: Sexual first person. III. Title: Women & men
write about self-pleasuring. IV. Title: Self-pleasur-
ing. V. Down There Press. VI. Queen, Carol, 1957- VII.
Sprinkle, Annie. VIII. Keen, Will. IX. Edroso, Roy.
612.6 or 306.772 or 301.417

ISBN 0-940208-17-2          LC 96-85336
```

Additional copies of this book are available at your favorite bookstore, or directly from the publisher:
Down There Press, 938 Howard St., #101, San Francisco CA 94103
Please enclose $18.50 for each copy ordered, which includes $4.00 shipping and handling.

Cover design by Gail Grant

Printed in the United States of America 9 8 7 6 5 4 3 2 1

To Betty Ann Dodson
for her pioneering work in liberating masturbation and
for teaching us that sex for one is *real* sex.

Table of Contents

Also by Joani Blank

Good Vibrations: The Complete Guide to Vibrators
Femalia (editor)
Herotica 2 (co-editor with Susie Bright)
The Playbook for Women About Sex
The Playbook for Men About Sex

for children and their parents

A Kid's First Book About Sex
The Playbook for Kids About Sex

Foreword

Masturbation is really a good thing. I'm not saying that it singlehandedly can save the world, but it has important benefits, and it certainly doesn't deserve the scorn and opprobrium it has suffered. The time has come for us to be bold, unashamed, and above all not giggly in our advocacy of masturbation.

It's hardly news that masturbation can play a significant role in public health campaigns to control population growth and the spread of sexually transmitted diseases. Less obviously, however, interesting new historical and literary research shows how masturbation and accompanying sexual fantasies have long contributed to human imagination and even to politics (Bennett & Rosario, 1996).

Sexuality can be subversive, as activists and theorists on both the left and right have long known. Literary and artistic depictions of masturbation symbolize resistance to authority and display an existential commitment to sensory and sensual pleasures. The widespread and sadistic medical suppression of masturbation in Europe, the UK, and the United States which began in the late eighteenth century is just beginning to wane as masturbation is recognized as a positive aspect of childhood, a central element of

sex therapy, and a centerpiece of safe sex strategies in the age of AIDS.

But, masturbation is far from being rehabilitated. Recall that Surgeon General of the United States Dr. Joycelyn Elders was fired—fired!—in 1995 because she suggested that masturbation be discussed in human sexuality education (gasp). Her defenders were numerous, but her indiscretion was just too extreme. Moreover, many of those who write about child sexual abuse, a moral panic of our time as the masturbation phobia was a century ago, continue to claim that children's masturbation is a sign of the premature sexualization they say results from abuse.

There is hardly any social science theory or research about masturbation, and as a consequence, we have little to talk about other than the simplest survey data or our own personal experiences. These are places to begin, but there's a lot more to say about masturbation other than that many or most people do it (what, exactly *is* "it", anyway?). Because masturbation has been so shunned and deprecated, the first wave of writings, as in this fascinating and provocative book, will inevitably be of the form, "See, I do it, and I'm OK." In time, there'll be more to say, about, for example, the relationship between masturbation and other kinds of physical and mental experiences or the relationship between masturbation and the technological and image-saturated sexualization of contemporary culture.

Among the most interesting aspects of masturbation are the accompanying fantasies. Our appreciation of sexual fantasy seems at present vastly undertheorized, and people are often defensive about fantasies they view as possible signs of psychopathology. Where do sexual fantasies come from, what ends do they serve, how do they change over our lifetimes, how are they related to class/ethnicity/ gender/religion/culture? In my clinical work, I see that discussing and unpacking masturbatory fantasies can pro-

vide insight for many people into the dynamics of their relationships with important others in their lives. Sexual fantasies turn out to be meaningful and interesting, not trivial or stereotypical. Describing fantasies as odd or seemingly self-destructive "psychopathology" is not very useful.

Patterns of masturbation over a lifetime can illuminate much about personality and sexuality, and some of the essays in this collection open the door to such understanding. Masturbation is part of our construction of the self in culture, both in terms of the way we regard and handle our bodies, and in terms of the accompanying mental imagery. As sex research moves towards a deeper appreciation of the subjective elements of sexual experience and the forces that impact them, masturbation will become a key window. Let the sun shine in!

Leonore Tiefer, Ph.D.
Author, Sex is Not a Natural Act and Other Essays

Reference: Bennett, P. & Rosario, V., editors, *Solitary Pleasures: The Historical, Literary, and Artistic Discourses of Autoeroticism* (New York: Routledge, 1996)

Acknowledgments

Many thanks to Leigh Dickerson Davidson, Marcy Sheiner, Charlotte Gutierrez, Molly Kenefick, Lydia Puller, Cathy Winks and Laura Mulley for their assistance in turning this collection into a book.

Introduction

Back in the seventies, I had the privilege of working
as a counselor in the Sex Counseling Program at
the University of California at San Francisco. The
program's participants were women who had
never previously experienced orgasm, and who learned how
by gradually approaching masturbation as their
homework, and verbally sharing their experiences in the
group. My contact with these women and with the
program's therapists gave me a new appreciation for mas-
turbation, my own as well as that of others. Whether or not
our clients ever learned to have orgasms during partner sex
(indeed, whether or not they even had sexual partners),
virtually all of them learned to masturbate to orgasm
reliably and joyfully, and finished the program far more
relaxed, self-confident and optimistic than they had been
previously.

One of the few texts for these pre-orgasmic women's
groups was an early version of Betty Dodson's soon-to-be-
self-published *Liberating Masturbation: A Meditation on
Selflove,* which remained a feminist classic for the next
twelve years. Since then, Dodson's book has been expanded
and is now in its second edition as *Sex For One: The Joy of
Selfloving.* This book, and the more recently published *Joy
of Solo Sex* and *More Joy...* by Harold Litten (on male

masturbation) stand virtually alone in their focus on this subject. Remarkable, is it not, that with the proliferation of both popular and scholarly books about sex, there are still so few about what is undoubtedly the planet's most common human sexual practice. One rarely sees an erotic short story, novel, or sexually explicit movie or video whose central theme is masturbation. It's as if all the new openness about the variety of options for partner sex has driven masturbation even further into the closet. With all these "new" things to do with a partner and with the willingness of more and more women to initiate sex and specific sexual activities, who has the time, energy or inclination to masturbate. Well, I do—and so, apparently, do the forty-three contributors to this book. They even had the additional time, energy and inclination to write about it.

Masturbation has never been highly regarded. "Why are people so uncomfortable about masturbation?" asks Leonore Tiefer, author of *Sex is Not a Natural Act,* in a recent radio interview. "Many religious teachings say it is bad or wrong. And much sexual discussion is tinged by embarrassment, discomfort, shame and awkwardness. Saying or believing that masturbation is wrong or bad with the authority of scripture behind you somehow justifies the negativity about it."

People go to great lengths to disassociate masturbation from other sexual expression. Only rarely do we refer to masturbation as sex or a sexual activity. Typically, there is jacking (or jilling) off, and then there is "having sex." Even the enlightened few who don't limit the phrase "having sex" to intercourse, virtually never include masturbation when they think or speak of "having sex."

Do we denigrate masturbation because we fear imagined judgments others would aim at us if they knew we did it? Are we fearful that a partner's masturbation says something about our individual inadequacies or about

defects in our shared sexual experience? Do we judge ourselves negatively because we do want to masturbate? For most of us, at one time or another, the answer to any or all of these questions is a resounding or an embarrassed "yes." These concerns reflect a profound suspicion of any sexual activity that has no conceivable rationale other than pleasure.

Certainly we appreciate pleasure in partner sex, but in rationalizing that pleasure we frequently fall back on love, the sacramental quality of sex in marriage, bonding, or just plain friendship—not to mention fulfilling an obligation or meeting the expectations of our partner. Moralists eschew the credo "if it feels good, do it," particularly if "it" has no apparent redeeming social benefit. But masturbation does feel good, very good in fact, and it does no conceivable harm. This is indeed sufficient reason to do it—with enthusiasm, in any manner and with whatever frequency one chooses. If not acknowledged for the simple pleasure of it, masturbation is meaningless.

Leonore Tiefer draws our attention to the connection between the crusades against pornography and the fear of masturbation. "The main use of pornography," she says, "is for masturbation. Everybody knows that. Those who report on, go on tirades, and who legislate against pornography never talk about masturbation. They say that pornography harms people's minds, warps them, and causes them to go out and do bad things. They never acknowledge that most people use pornography to enhance their masturbation fantasies. A lot of the fuel for the anti-pornography crusades comes from anxiety and awkwardness about admitting that people masturbate."

As I collected the stories for *First Person Sexual,* I was struck with some of the differences between stories written by men and those written by women, two of which are noteworthy. Although I specifically asked contributors not

to fill their stories with masturbation fantasies with little or no description of the masturbation itself, quite a few of the men did exactly that. I also asked that contributors not describe a lot of sexual interaction with a partner. However, a significant number of women (and a few men) did just that. This led me to contemplate some questions about the place masturbation holds in the sex lives of men and women. With luck, the following speculations will fuel conversation, and will perhaps provoke letters to the editor.

Do men who masturbate—virtually all men—tend to distance themselves from the pure physical sensations while they focus on the fantasy? Do fewer women than men masturbate in part because those who feel too guilty or too fearful simply don't do it? Apparently men masturbate most during periods when they are having not enough partner sex, or none at all, while the more partner sex a woman is having the more she is likely to masturbate. Why is this? Although some women masturbate before a sexual encounter to get "warmed up," men apparently do so rarely unless they are trying to avoid ejaculating prematurely later. Women who masturbate are often willing and eager to try new positions, locales, techniques for their masturbation, while adult men commonly masturbate pretty much the same way they did as adolescents. Why would this be the case?

In the course of my work at Good Vibrations I was frequently asked if, given the danger associated with unprotected partner sex in these times, people are masturbating more—presumably using more sex toys and fantasy materials. Masturbation is, after all, the safest of all sexual activities. Surely more sex toys, books and videos are sold today than ever before, especially to women. And some of these toys and materials may be used by people who are enhancing their masturbation practice as an alternative to partner sex with its attendant real or imagined dangers.

It is also possible, however, that many of those who fear and therefore avoid partner sex, masturbate significantly less than they did previously. Some of these men and women expect that masturbating more will turn them on and leave them feeling frustrated because they don't want to have sex with a partner. Others find that masturbation brings up feelings of loneliness. Still others simply feel so "shut down" sexually that they rarely experience any desire for sexual arousal or orgasm. As suggested above, to the extent that people are having partner sex less frequently, men may be masturbating more, and women less. Fortunately, most people seem to be masturbating much as they always have, and increasingly couples are making touching themselves in each other's presence a regular part of their lovemaking.

Only three or four of the stories in this book are fiction. I haven't identified which they are because it doesn't matter. Not every story here is well crafted. Well over half of the authors are not writers; a few literally tore pages out of their journals. My experience suggests that people who are willing to share their writing about their own sexuality usually express themselves very well. These contributors have not disappointed in that regard.

A half dozen of these stories were originally written in the third person; in each case, I asked the author to rewrite his or her piece in the first person. Although a few expressed fear of doing so, all obliged, and I was pleased with how much more immediate and personal their stories became. Several contributors felt that readers would be able to identify with them more easily now that their stories were written in the first person. In the midst of one of these conversations, the title of this book first came to my mind.

For some reason it did not occur to me that so many of these stories would be sexually arousing to readers. So I was pleasantly surprised to find how many of them were.

Whether or not these stories turn you on, learn and enjoy. At its best—perhaps even at its worst—masturbation *is having sex with someone you love* (a thought attributed to Woody Allen). So, from time to time apply Good Vibrations' slogan, "If you want something done right, do it yourself."

Joani Blank
San Francisco, June 1996

References:
Dodson, Betty, *Sex for One: The Joy of Selfloving* (New York: Harmony/Crown, 1986, 1996)
Litten, Harold, *Joy of Solo Sex* (Mobile AL: Factor Press, 1992)
Litten,Harold, *More Joy...* (Mobile AL: Factor Press, 1996)
Tiefer, Leonore, *Sex is Not a Natural Act and Other Essays* (Boulder: Westview Press, 1995)

Home Alone

Thea Hillman

Sometimes I'd rather fuck myself than leave the house. I center the whole day around masturbation. Wake up, eat my cornflakes, clean my apartment, come with my vibrator, vibrator and dildo together, vibrator once again. Fall asleep. Read. Masturbate. Talk on the phone. Masturbate, read, not even wondering if I'm depraved or thinking that it's weird that I haven't gone outside all day, that I came six times today.

It's sweet the way I masturbate when I'm sad, when no one's been as nice to me as they should be. Self-pitying tears mix with moans, as sharp intake cry-breathing turns into cum-breathing and I start feeling hot and all of a sudden I'm a sexy fucking number, coming hard, forgetting whatever went wrong and remembering how much I get from myself and how much I mean to myself.

I love the sounds I've been hearing lately, that no one taught me how to make—funny, awkward, deep sounds that come from my belly and from my clit. Sounds expressing wonder, fear, anticipation, that sound exactly like me.

I love the stories I'm not afraid to tell. Grabbing my brother's penis under the bathwater when I was little, letting the cat lick my pussy. Or watching my guilty flush as I recall playing "I'll show you mine if you show me yours" with my cousin after he showed me the porno movie, "The

Budding of Bree."

I love the questions I'm not afraid to ask. Asking my mother, "How do you masturbate?" And me, dissatisfied with her answer about how people touch themselves and me insisting further, "No Mom, how do *you* masturbate?"

The book she got me the very next day suggested looking at yourself in the mirror, so I crab-walked up to the mirror on the back of the bathroom door and that's when I realized it was true—I did have two holes. Which of course I had to explore. And it was kind of tight in there. And then I discovered Vaseline.

I love the way I get off on everyday occurrences. Walking down 14th Street, the setting sun like breath on the back of my thighs.

I like my late-night posing in front of the mirror, making my cotton underwear sexy by pulling up the corners and lifting my faded olive-green t-shirt just-so to showcase my belly curves. Or rubbing my clit while reading *Cold Sassy Tree* to test whether I can come while immersed in rural Georgia in 1906. And I can.

And I still haven't left the house.

Two Palms Oasis

Will Keen

I walked alone among the Joshua trees, breathing the
savory early morning air, warming to the desert sun.
As I moved deeper into the bare landscape of the Lost
Horse Mountains, my body was working itself free
from the grip of the city. A solitary oasis, marked by a
cluster of palms on the map, beckoned in the desert to the
east of me. I headed that way, hiking a stream bed, tracing
the flow of the phantom water back to its origin. For miles
my only company was a band of pinyon jays raucously
foraging along the ridge line above.

Far up the dry sandy wash, my trail abruptly ended at
a high wall of polished stone. I was brought to a halt, but
didn't really care, taking it as a sign to rest. I sat down,
shrugged off the backpack and stripped off my shirt, then
leaned against the sheer cliff to soak up its heat. On this
spot, maybe once or twice a year, a waterfall would pour
over the cliff edge, then churn its way downstream. I
enjoyed sitting in the path of the virtual flash flood, at peace
with the silence of cactus and rock. No one knew where I
was, no one could see me, hiding out in a nameless box
canyon under blue sky.

As the sun rose, the huge boulders around me shifted
with the shadows, and I began to notice their extraordinary
forms. Reddened and sunbaked, the imposing granite

shapes lay tumbled and scattered along the arroyo. Wind and rain had eroded the rocks, revealing their smooth inner cores. Some of the rounded ones were so perfectly weather worn they appeared to be giant carved nudes. A pair of monoliths reminded me of trunkless legs of stone, while others sat as steady as yoginis holding timeless poses. These rocks were formed into tanned and inviting lovers, women with great curved buttocks. I approached a large granite figure, running my hand up the hard flank to a truly maximum gluteus, feeling her heat radiate from the rock.

I turned to press my back against the body of this earthen creature. I let the warmth penetrate me from the behind, as the sun caressed me from the front. I closed my eyes for a moment, and the rock began to shift, lifting from the ground, shaking off the sand, pressing into me. I relaxed into the fantasy...awakening a massive goddess from her slumber. Energy was moving in me; suddenly I wanted to stand as naked in the desert as the stone yoginis. I shed the rest of my clothes, delighting in the freedom, exulting in the flood of light on my skin. I took a handful of sand and rubbed it on my chest—it felt good, scratchy and enlivening. I played with the idea of making love to the clefts in the beautiful sun-glazed rumps bending down before me.

I was becoming aroused, and as my cock felt the first flush of blood, I tugged at the foreskin, wriggling it between my fingers. I stretched it out full length, responding to the ambient seduction. My cock hardened to its own kind of supple stone. Instinctively, I licked my right hand and began sliding it smoothly along the shaft. I tensed my legs, pushing my heels into the sand to lean back more firmly against my sensuous stone goddess. She met me with equal strength, supporting me as I swung my hips away from the rock. As my pelvis thrust forward, I closed my eyes again and saw the native rocks dancing in my head, swaying their

rear ends at me, teasing me. I stroked faster, tingling, alive to the rare sensation of having the sun warming my erection, fully exposed to the brilliant light. I gripped my cock with both hands, both palms sculpting it with friction and heat. As I stroked and thrusted, I was breathing deeply, working the grit of the rock surface against the skin of my back and ass.

Soon I was shaking the sides of the canyon, making love to the land. I merged into the rock behind me, her heat a palpable presence, pushing back at me as I stroked the desert to climax. My breath became ragged and I fought the impulse to use my cock to chisel the stones surrounding me. I came hard, my whitewater falling in spurts to the desert floor as I let out a loud howl that bounced off the canyon walls. I laughed at the unexpected echo reminding me that I was making love to myself. When I opened my eyes, my stone lovers still held their positions, immutable.

My legs quivered for a bit from the pure body release, so clean in the limitless light and air. I felt relaxed, at one with the vibrant desolation of the canyon. I stretched my muscles, reaching down to touch the moist place where my semen had fallen; it was already soaking into the porous soil. The beginning of an oasis, I thought. My seed would stay buried here until the next gentle rains brought it to life. Or better yet, there would be storms! Yes, thunderstorms would come to penetrate the sands, moving underground to carry me down the wash, spilling into all the ephemeral streams of the flood plain until I was spread across the entire desert.

A Woman Unto Herself

Stacy Reed

The apartment was still when I came home. I paused by the door to turn on the light and step out of my heels. Tom was asleep on the sofa, his collapsed penis cupped in his hand. Videotapes of himself masturbating were stacked on the coffee table.

I padded softly through the den to the bathroom. I peed and washed my face. If I flushed the toilet, Tom might wake up. I hung no mirrors in my room and had shattered the two that had been in the bathroom. Tom had asked why.

"I know what I look like."

He hadn't asked again.

That was a lie. In truth, I was captivated by my appearance, startled by my changing reflection, infatuated with my ability to metamorphose. But strangers' fascination with my countenance, my structure, had created in me a contempt for my own vanity. Regardless, the experiment was useless. Since it was all for me anyway, I continued to apply cosmetics blind, wear perfume and adorn myself rather than dress.

Reaching a long braceleted arm behind me, I unzipped the minuscule black dress I had worn on my evening out. It fell to the wood floor and I laid it across a chair. I wore no underwear and I fixated on this as I unscrolled my long black hair. I regarded myself: small tits, hard stomach,

bulging thighs. I'd been a gymnast until I finished school. Now all I could fit in was weights three times a week.

I bent over, rolling down one silk stocking. I admired the lace that bound my thigh and ran my finger behind my knee to feel the seam running down my leg. After letting the other fall, I set them with the dress.

This bedroom was my favorite part of the small house that Tom and I rented. I'd come to think of it as sort of a porch. (Three large windows interrupted every wall but the one the doorway occupied.) A vine grew through a crack high on the eastern window and had rambled across the ceiling. The pines flooding the backyard dappled the light during the day and shadowed the moon at night. I pulled the curtains and opened each window. I'd removed the screens once summer had ebbed, and I now perched in the southern window's frame, leaning languidly against the splintering wood. I dangled a leg over the sill like bait, my bare toes fondling the ferns and vines that overgrew the perimeter of the house.

I ran my hand through my hair, petting myself. I lifted it up from the nape of my neck, stretching my vertebrae. The wind seemed cleansing and I dragged my outstretched leg into the frame, letting it stir the lush hair between my thighs. My toes curled and I rested my elbows on my knees, feeling indulged and smug. I preferred life my way.

Going to the movies with another person was so tedious, for example. They tended to ask questions, make comments. Get popcorn. Pee. It was the same with a play or an exhibit. I viewed such people as impediments to my serenity. Besides being intrusive, they were dull. With few exceptions—among them, Tom—I preferred solitude to company.

I closed my eyes and sniffed for possible voyeurs, then began tugging at my nipples. I toyed with them until I felt tumescent and wet. I continued to pinch my nipples, rolling

them gently as I felt impatience rise in my pelvis.

My hands moved down to my pussy, pressing my clit softly from behind my lips. Spreading my legs, I traced them, then dipped my finger into my vagina and returned to clitoris. I ran my fingers along either side of it, pinching gently. I breathed carefully to keep silent as I dragged my fingers across my clit.

As I sat in the windowsill, I flicked my clit lightly, ruthlessly, not letting myself come. The backyard was dark, a tangle. A breeze whipped the low-hanging branches and as I massaged myself deeply I felt my vagina flex. As each orgasm subsided I threw myself into another by changing pressure, rhythm, pace. No one else could do it like that.

A knock came at the door.

"Are you awake?" Tom asked quietly. Sperm had dried on his chest, but he seemed oblivious.

"Yeah." I admired his timing.

"Have you seen the Astroglide?"

"You put it in the fridge. Remember, you thought it would be interesting."

"Right. Do you have any K-Y?"

"Don't need it."

"Of course. Um. Do you mind if I sleep with you tonight?"

I rolled my eyes. "Yes. I've already had a good deal of amusement. I'm exhausted."

Dejected, Tom closed my door softly behind him. I heard him open the refrigerator and as I dozed off, the whir of the microwave where he would be warming a bowl of lubricant.

Under My Thumb

Raye Sharpe

I usually masturbate when I procrastinate. They would rhyme of course, the bastards. Like today. If I hear the word "deadline" once more, I swear I am going to kick somebody. I'd love to fuck buzzwords up the ass and have the rest of the dictionary bleed out. I'd grab onto "brainstorming," thrust into "mission statement" and come all over "win-win." But I digress.

I'm lying in bed. I'm supposed to be doing a lot of things—paying my bills, tackling the monstrous laundry pile, writing my annual report. But what am I doing? Twirling my nipples. The "zing" of arousal connects directly to the nub's hub between my legs. I spread my thighs over my proofread pages and crumple white bond sheets between my knees. Twirling becomes rubbing forward and back with my palm. I trace my love and life lines with a brown-nippled breast. I tell myself I shouldn't. I have too much to do! What am I accomplishing by dipping my fingertip and thrusting my hips back and forth? Wetness. Fluid that's slimy and good. My editor would lecture, "You've got to set your priorities." Priority one at the moment is circling my hard clit.

I think of an old boyfriend's cock. I had to wrap both hands around to stroke him. It drove him crazy when I did it and he'd cry out, "No! No!" but I'd squeeze my hands around him tighter. This isn't going to be a fingertip night.

This is definitely going to be thumb action. Whole hand even. A pastiche of imagined tongues, hands and mouths floods my brain.

I grab both nipples in my right hand and slide my left thumb in. It's always the left hand in tribute to my Catholic upbringing. My left strokes in homage to the nun who tied that hand to a kindergarten stool to enforce right-handedness. My thumb sinks in deeply and the first knuckle, that wild interphalangeal joint, presses against my insistent clit. I'm riding my hand slowly back and forth. Pressing in feels slippery and encompassing, pulling out is resistant and teasing. Every time I pinch my nipples I press down onto my thumb. I imagine the hip I'd bump against, the rough hands that would grab my ass, the lips that would suck and caress. My thumb stays hard, my thumb doesn't lie.

I stretch with a fingertip back to reach my ass. I picture a love god in front of me and a dildoed love goddess skewering me from behind in the name of sex. I'm starting to come on this thumb. My inner ridges convulse against my fingers. I feel softer and juicier inside. The familiar swirling sensation rises in my thighs, my nipples harden and my mouth is watering. I picture that old boyfriend looming above me. I would grasp his waist and pull myself up onto him. I thrust my whole hand in and push back onto the finger in my ass. I'm gyrating harder and faster until the levee washes over in sweat and exclamations of "Fuck! Suck it!" My thighs shake, my ass tightens and each syllable of orgasm pumps juice all over my vaginal mouth. The inner spasms pull up into my lower abdomen. Come floods onto my hand and thighs. I've fucked myself silly. I move the papers out of the way as my legs fall open. I leave a musky yellowish thumbprint on the top sheet of my annual report. In French, left is *gauche,* in Italian, it's *sinistre.* To me it's lover.

No Summer Fling

Anne Semans

I caught my first glimpse of her lying heated and spent on the bed. I approached curious and mystified: she was so small! I'd heard rumors about her incredible amorous powers, but she didn't look anything like I'd imagined.

I wanted to touch her but hesitated. After all, she belonged to my best friend and they had just spent an intimate morning together. I know because I was in the next room of our apartment, listening. They had aroused both my curiosity and my libido and my own desires needed attending to. Kate wouldn't mind, I rationalized; we had shared lovers before.

But wait! We couldn't do it on the bed where they had just done it. That would be rude. Besides, I wanted someplace special for our first time. The kitchen floor would work. I shivered, imagining the coolness of the tile against my skin.

I picked her up and carried her into our tiny kitchen, but she remained motionless. I lay on my back and propped my feet up against the wall, then positioned her carefully between the wall and my wide open legs. I began stroking her smooth body.

Instantly, she sprang to life and went straight for my clit. She knew instinctively how to please me—teasing me,

varying in pressure, changing her speed. She was so focused in her attention to my clit that I came quickly in one long, felt-it-in-my-toes orgasm.

Well, needless to say, she was better than I'd ever expected. I spent the entire afternoon with her, savoring one delicious orgasm after another. She would occasionally become a bit overheated, but having to wait while she cooled down only made me want her more.

I'll never understand the sparks that flew between us that day. I fell instantly, hopelessly, shamelessly in love. Since then, I've spent some part of almost every day of my life with her.

Look At Me

Norm M.

I was fresh out of school and in my own apartment. I had some friends over and we were drinking beer and listening to music. A bad storm had just hit and we were looking out the sliding glass door that led to my porch. We did not believe our eyes when we saw a neighbor walk by her window with only a towel on, and were shocked when she walked by a second time completely nude! I was so excited that I had to change my shorts because they were soaked with precum.

Much to our dismay, she did not repeat her display. However, this did not diminish my interest and I decided to return the favor. When I was on the phone with my girlfriend, I'd walk into the kitchen and masturbate, and then walk out into the living room so my neighbor could see. When my cock started to get limp, I'd pace back into the kitchen again, stroke it, and then let her see me again. I never did work up the nerve to masturbate in front of her. Generally, I finished my flash session with a long masturbation session in my bedroom.

Another time I masturbated till I had a big erection, then wrapped a towel around me and went back into the room that was in full view of the neighbor. I turned on all the lights and stood on a chair right in front of the window while I watered the plants. As planned, the towel acciden-

tally fell and I continued to tend to the plants nude and in full view of the neighbor. I looked over and she had taken a position right in front of her window and was staring at me and smiling. I pretended that I did not see her. After she left for work, I took a long shower and masturbated thinking of her.

I once took photos of myself masturbating. With a closeup lens I took shots of the precum forming all the way to shooting my load. I took the film to the local photo shop. When I picked the pictures up, I could tell from the smile on the woman behind the counter that she had looked at them. It was almost as if I had masturbated in front of her!

Eventually I worked up the nerve to visit a Japanese health spa. I shaved my balls completely before the visit and stripped completely before the masseuse got in the room. She stared at my groomed bush and asked me to lie face down on the table. I made sure that my cock was pointing straight down towards my feet as I lay down.

She started with my back and eventually worked down my ass. She took the towel off my ass and kneaded my ass cheeks. I got an erection and since it was pointed down, I know that she saw it. When the massage was half finished I was horny as hell and knew I didn't want to leave there blue balled, I asked her if it was okay to touch myself. She said sure and poured some baby oil into my hand.

For the remainder of the half hour, I slowly masturbated while the masseuse stared at my cock. We talked and I explained that I had always wanted to do this in front of a woman but never had the nerve. She seemed to like it as well 'cause she never took her eyes off my erection. She asked me to show her what felt good and I did. It was so erotic having myself completely exposed, masturbating in front of her and telling her what felt good. She told me that our time was almost up and that I should finish. She got a tissue and positioned it to catch semen. I was stroking

faster now. I asked her to watch this trick and just when I was ready to cum I started slowly stroking in one direction only. Down, let go, then down again. I told her that this makes that ticklish feeling before coming last longer. She smiled and caressed my upper thigh. I started bucking up and down, felt wave after wave of pleasure and came in gobs.

She said to not move, that she would be right back to clean me up. She came back with a wet washcloth, picked up the tissue and tossed it in the trash. My cock was still hard and twitching from the orgasm. As my cock got limp, she squeezed it and wiped up the cum at the tip. She told me to dress and left to throw out the trash.

When she returned I gave her a tip and told her it was nice but that I missed the closeness I feel when making love with my wife. I told her that I would try this with my wife. She said I was a wise man and that it would be better with her.

I have since masturbated in front of my wife and am now completely open about it. If I wake up in the morning horny and she is sleeping, I just grab the lotion that we leave on the nightstand and stroke away. Sometimes she wakes up and joins in, or we make love. Sometimes she just wakes up and watches. I no longer feel guilty about masturbation and treat it as something completely natural.

My Lover, Myself

Dorsie Hathaway

lmost bedtime. I smile as I make preparations. Once, a night like this would have left me feeling lonely and frustrated. Lovers have passed though my life, my home, my hands. My tastes have changed; solitude, once threatening, has become a pleasure. I now look forward to time with myself.

I like the feeling of the silk nightshirt against my skin. I light candles in the bathroom and run a hot bath, with hibiscus-scented bubbles. Undressing, I smile at my reflection. Lowering myself into the heat, I begin to relax. My face, lit by candle fire, is mirrored by thousands of bubbles.

I rub almond blossom soap into a sea sponge, and begin to wash, lathering until my skin is warm and tingly. Finally, I stand and turn on the shower, using the spray to wash my hair and rinse the remaining bubbles from my skin. Stepping out of the bath, I wrap myself in a large towel.

Waiting for the teakettle, I browse though my music collection. I put on my favorite night music and carry the mug of tea to my room. I light candles, and turn down the sheets on the heavy four-poster bed. Seven generations of women in my family have been born, made love, and slept in this bed. Perched on the edge of my bed, naked and warm, I hum and smile to myself. Sipping the fragrant tea, I open the nightstand drawer.

I lift out a black collar. Crafted of fine lambskin, it is laden with an intricate network of looping chain. The collar was a parting gift from a woman who gave me lessons in submission. It symbolizes my freedom to desire, ask, be, or do anything, with any woman. Tonight I will desire, ask, be, and do with myself. I fasten the collar with a heavy snap. The cool leather and the cold chain give marked contrast to my hot skin, still damp from the bath.

I take out a red silk scarf. This, too, holds memories. As I slide into bed, the flannel sheets warm me. I lean back against the stack of pillows and begin to touch myself with the scarf and my fingers...running them over my inner thighs, belly, and breasts. My body hums, call-and-response, as each touch echoes itself above and below. This is an ancient, intimate harmony. The dresser mirror is tilted so I can see myself. I smile at my lover, framed in the darkness and light. I want the woman I see there.

My fingers drift lower...I stroke myself, beginning at the inside of my knees, and heading upwards, in long, slow, passes. As my fingers caress my skin, my breath comes more deliberately. The collar is warm now. I leave the scarf loose on my breasts and belly, and focus on my pleasure.

I watch, caress, open to myself. I begin to play with my labia...fingers shifting up, down, around, pulling, pushing, eyes closed as I concentrate on touching and pleasing myself. My fingers come home, completing the cycle, and I arch forward against them, wanting more.

The circle of pleasure spreads, warms me, takes hold. Breathing faster now, my nipples hard against cool silk, I feel the leather close and warm around my neck. I bring my fingers to my mouth, and suck them while touching myself with the other hand. I slide my fingers deep inside, squeeze, and feel myself all skin, bone, muscle, pleasure and heat.

My cheeks and breasts are hot; the room is aglow. In the mirrorlight, I see my lover fully. This woman, my lover,

knows all my secrets, desires, pleasures, and needs. For a long moment, my energies are centered, the heat from my body, the room, the world, circling at my core, becoming sun, star, supernova. I give myself up to my lover, and come, calling out my pleasure in the night.

Sermon

M. Christian

Sure, I masturbate. Yeah, I jerk off. Damned straight, I yank it, pull it, stroke it, rub it, and jerk it. Lube, soap, shampoo or spit. Left hand, right hand, frottage (look it up), other's hands, sheets, and gizmos (manual, electric, and even diesel). Like it, love it—do it a lot.

Let's get this straight—we all do it. Sure, yeah, right: "not me" you say. Sit the fuck down and shut the fuck up. We *all* do it. Nuns do it, dogs do it, bees do it, Newt Gingrich and Jesse Helms do it (God what a thought!). You say you don't do it? You mean it when you say you don't do it? Well then, what leaves the wet spot on the bed, a topless Tinkerbell?

I masturbate. Come on, syllables, "I"—rousing chorus of self-identification. Come on, belt that fucker out—*"I"*—mean it now, say it true—"mas-tur-bate."

I masturbate. He masturbates. She masturbates. They masturbate. We all masturbate. That out of the way? Breathing maybe a little easier now? Let me tell you this, the cliché of imagining folks in their underwear has zilch over thinking of you sitting there rubbing, stroking, jacking, and jilling yourselves into a euphoria of self love. Makes saying that I do it real easy.

I masturbate. Bullshit on that "self-abuse" nonsense:

think of that preacher sitting on the toilet in some sleazy dive yanking his little wiener with two embarrassed fingers, groaning like he's taking a shit, popping off an eye-dropper of fun cream, wheezing like an asthmatic marathon runner, then going out onto the pulpit to tell you that it's bad for you, it's sinful, it's detrimental.

I do it. I'm proud that I do—because I do it well (hell, I like it) and I do it often: horny, need to sleep, need to relax, wanna get off quick, wanna get off slow, got a cold, don't got a cold, at home, driving, sleeping ("Yeah, Tinkerbell, yeah!"), for myself, with others—available for weddings, bar mitzvahs, etc.

Been doing it for years (first time I think something like twelve—late bloomer); I will do it for many more. Do it tonight, do it tomorrow, do it with my wife, do it with my playmates, do it for pay (if anyone's interested), do it for free. Ask me to, go ahead, ask me. You can see me do it, you can hear me do it (the movie's out there somewhere—sorry they never told me what the title was going to be) and I write about doing it....

I stroke my long, proud self, feeling the soft skin and the ridges and bumps of the veins. Relishing the feeling of my palm gliding over and squeezing the thick head. The pressure, the wonderful feeling of tension that cranks me up and away. The pressure in my balls, the pulse at the head as my hand cups and then pulls back from it. The tiny pulls and sharp little plucks of my forest of pubic hairs getting caught in my hand. My asshole getting nice and tight. My grip getting firmer as my cock gets harder. When it's good it's very good, and my cock is an iron putter wrapped in fine silk. My cock is a divining rod pulling my brain this way and that with images and sensations: entering, sucking, licking, biting, beating, feeling, touching, and more, much more.

I love to start the trip to see where it might detour. Start

out with a fuck-film in my head, maybe a thought of that one night, that one day (satin, silk, polyester, latex, leather, cotton, elastic waistbands) and let my cock take me through side-trips of past fucks: just that sensation, that picture, that image, that fantasy, that lover, that glimpse, that night (or day). I might start with the Standard Number Four fantasy: big tits in my face while she jumps onto my rigid cock, and I might end up in a mobile home somewhere below the Mason-Dixon line with a scummy teenager (all zits and no tits, chewing gum and smelling of piss and booze) on my face while some guy named Joe-Bob bathes my cock in cheap beer. It ain't so much the destination as it is the trip.

I jerk off when I'm horny. I stroke it when I'm excited. I pull it when I'm turned-on. I also yank it when I'm bored, can't sleep, have a cold, have a headache, or can't think of anything else to do (or there's nothing good on TV). I do it in bed, on the john, in my living room, at my computer (I give good e-mail), in the backyard, and everywhere in between. I've done it driving, in planes, in porno houses, in trains, and when I shouldn't have been doing it and I'm damned lucky nobody caught me. Don't act so surprised, a lot of you have done a lot worse—or a lot better.

Stigma? Masturbation should be prayer. It should be the way we show our love for the God/dess in ourselves (how better to show him/her/it a really good time?). We should have it fucking institutionalized. No more of this bullshit white-haired old men yelling at us from inside their million-dollar temples about a hateful God that forbids us to yank it or rub it. Nah, we should tune in every morning to the right kind of prayer—"Put your hands where they belong, Brothers and Sisters, and give unto yourselves the pleasure that is God/dess's gift to you. Rub yourselves with me, dear people, feel the rising power of prayer in you—and remember to clean up afterwards."

Jerking off should be a fucking sporting event! "Live from the Superbowl—the longest ejaculation, the most powerful orgasm, the most orgasms (women's and men's divisions), and the quickest (the longest takes way too much time for television)." Personally, I favor the San Francisco Queens (got ten bucks riding on them, too).

It should be taught in school, it should be continuing ed, it should be an extracurricular activity ("Today, class, we are going to examine the social, personal and physical repercussions of long fingernails...."). It should be part of the glee club (high notes), cheerleading, and shop (bookends, sailboat, coat rack, dildo, buttplug...). We should be shown and told how to do it well, safely and effectively.

It will. Maybe, maybe, maybe. But for certain it is harmless, natural, comfortable, common, and—best above all else—a helluva lot of fun!

I know you masturbate. I know you do, because I do. A lot. So get off it, get on it and—love thyself, dammit!

Taking Myself In Hand

Sue-Marie Larsen

I discovered my clitoris when I was twelve years old, while watching TV in the family room of my parent's house. As I was mindlessly stroking my inner thighs through my jeans, my hand moved up to my crotch where I was surprised to find that one spot felt especially good. This little taste whetted my lifelong appetite for pleasuring myself.

The year was 1974, an era of sexual exploration and freedom, which must have been why my mother told me that masturbation was healthy. She said almost everyone did it, and that people who claimed not to were probably lying. Being an outspoken kid to begin with, I promptly relayed this news to as many of my seventh grade classmates as I could. Thus began my sexual activism; I'm very proud to have started discussing sex publicly at such a young age!

Initially, I masturbated by placing the first two fingers of my right hand on either side of my clit, where I would sort of tap them up and down rhythmically. This moved my clitoral hood up and down on either side of my clit, causing enough friction to bring me to orgasm. I don't think I fantasized much, though if I did it surely would have been about my best friend, Lizzy, who lived next door and was a year older than me and significantly more developed. She

had the perfect little sex kitten body, even at age thirteen and I loved her deeply, and actually masturbated to thoughts of her and her gorgeous breasts all the way into my early twenties.

One day after school, about a year after I'd first found my clitoris, Lizzy reshaped my solo sex life with a simple question: "Do your parents have a vibrator?" As it happened, they did. It was an old aqua-colored thing from Sears, which they kept in a box in the headboard of their bed, next to my father's handgun and stack of *Playboys*. The vibrator was one of those heavy, clunky old plug-in types, with two knobs and a half dozen attachments.

Lizzy told me to go get it, then pulled me into my parent's bathroom, which had a thick pile rug on the floor. "Lie down," she demanded, with an odd little smile on her face. "I'm going to do something to you that you'll really like. Just trust me." I was confused, but I would have done anything for Lizzy. Following her instructions, I lay on my back on the floor. She plugged in the vibrator and started moving it up my thighs towards my crotch. I must have looked terrified, because she began quoting Marvin Gaye lyrics. "You don't have to worry if it's wrong, if the spirit moves ya, let me groove ya, let your love come down." Then she placed the vibrator over my clitoris and I just about leapt out of my skin. It was much too intense. We stopped immediately, unplugged the vibrator, and never repeated the experience.

I was a changed girl after that, though, and the vibrator became a regular part of my jack-off repertoire. Since my father's *Playboys* were kept beside the vibrator, it seemed logical to start looking at the pictures while straddling the vibrator. I kneeled on my father's side of the bed, a pillow between my legs with the vibrator on top, as I moved my crotch against the vibrator, using both hands to flip hurriedly through the pages of *Playboy*.

The vibrator gave me a quick and intense way to get off. Usually I straddled it while fully clothed. Other times I pulled down my pants but kept my panties on. If I was the last one out of the house, I got off before going to school. I was frequently the first one home, and got off then as well. Sometimes I declared a mental health day for myself, feigning illness to get out of school so I could stay home and masturbate in peace and privacy for hours.

With the vibrator, having orgasms was definitely the goal. I never used it for more than five minutes. One time, while waiting for some parents I babysat for to pick me up, I sat on the vibrator, opting to satisfy my last-minute need to get off just once before starting what I knew would be a hectic day of babysitting. The parents drove up and began honking the horn as I was right on the edge. The urgency fueled an explosive orgasm to the sound of the honking horn outside. I had become very good at putting that old aqua-colored vibrator back in its box at lightning speed, running down the stairs all fresh-faced and happy-looking, the picture of a normal suburban teenager.

In eighth grade I was still enjoying my parents' vibrator. In one moment of exuberance, I told my mother about it, urging her to try it out for herself because it was so fun. She looked a bit surprised, and said, "That thing is awfully strong!"

During an after school discussion about vibrators, a junior high pal confided she'd been wondering if the family TV made static when she used her mother's vibrator in her closet. We decided to do a test, but we couldn't find the vibrator. My creative friend ducked into her father's garage and came back with his electric sander! I was shocked. This thing weighed about five pounds and had a heavy black cord. She wanted me to put this big old manly thing on my delicate little pussy? "We can cover it with towels," she explained brightly.

Terry went into the closet first, while I casually went out into the living room to check on the TV. No static. When she came out of the closet a couple minutes later I told her all was clear. She wanted to make sure, so then I went into the closet with her big vibrating rig. I came close to coming, but what with my friend outside the door and her father and little brother watching baseball in the next room, I felt pressed for time. Frustrated, I gave up and abandoned my mission, only to be chastised by Terry. "Gawd, you were in there for a long time!" she said. This was the first time I ever felt ashamed of my desire to make myself come. It was confusing to me, because moments earlier she had been the one encouraging me. It would be years before I would masturbate around anyone else again.

When I was sixteen and started dating my first boyfriend, I explored the joys of stolen orgasms myself, waiting until he fell into a deep sleep, then rubbing my clit against his leg until I came. Although it seems an odd way to come, part of the joy was the stealth of it all, having to be very quiet and rub against him enough to get myself off but not enough to wake him up. This was fun, but it started giving me headaches. In order to remain silent, I had to suppress the outward release of energy a bit, and this unsettled my nervous system. It was as though the built-up energy was unable to leave my body completely.

A few years ago I learned a new way to pleasure myself, which stemmed from my extreme distaste for housework. I was home alone, wondering how to motivate myself to scrub the bathroom, a task I find utterly tortuous. I worked out a little sexual domination scene with myself designed to get the job done and guarantee some level of fun for myself. I fashioned a rope harness around my body applying delicious pressure to various body parts. I especially enjoyed tying up my breasts. They got extra firm and round, just like the breasts I'd seen on the women in those old *Playboys!*

Next I put nipple clamps on my nipples, then clamped a layer of clothespins onto each of my outer labia. Then came high heels, a mini-skirt, and a trashy-looking top—the kind cops wear when they hit the streets pretending to be prostitutes. By this time, my pussy ached with that sweet mixture of pleasure and pain, and I began lubricating profusely, feeling the slippery wetness running down my thighs. I got tremendously turned on, but I wouldn't let myself touch my clit or get off until the bathroom had been thoroughly cleaned.

Lately my favorite way to masturbate is to spend an evening at home by myself, watching porn videos while rubbing my clit with a vibrator and fucking myself with a dildo. Often I dress for the occasion, even though no one else can see me. I enjoy dressing provocatively just for myself. This is the essence of masturbation. It's a celebration of myself, my lust, my sexuality, and my creativity.

To this day, I am convinced that the best way to have really great partnered sex is to have really great solo sex. I don't know one woman whom I consider the mistress of her own sexuality who has not spent considerable amounts of time masturbating. If you don't know what you like, how can you possibly let your partners know how to turn you on? Hands down, masturbation has been the single most important tool I've used to create an outstanding sex life for myself.

Guys and (Blow-up) Dolls

Emile Zarkoff

The first blow-up doll I got was Yoko. I had been wondering why men went for inflatable dolls for some time, but my curiosity had never quite overcome the forty to sixty dollar price tags I had seen. One afternoon I was careening around town with Val (short for Valkyrie) as she gave out literature for a Feminists Against Censorship campaign. We were going to adult bookstores since Val reasoned that they must want to fight censorship; maybe they would even contribute to the cause.

Generally, the bookstore clerks took one look at Val and panicked. At nearly six feet and 180 pounds of hard muscle (but for her lovely soft tits), Val might convince even Grace Jones to reread Emily Post. Usually after a couple of minutes of intense harangue, the clerk would get it and promise to pass the literature on to his boss.

One store was having a sale on blow-up dolls, and I confided my secret fantasies to Val.

"Well, why don't you get one and try it out," she offered. "They're cheap today."

Val always lifts the lid on my inhibitions a little, so I thought, "Hell, I'll go for it!"

I fell in love with Yoko at first sight and trundled her off to the cashier. Val found a boy blow-up doll which she purchased and promptly named John.

We hurried home with our new found friends. After a little huffing and puffing we were soon seeing what John's and Yoko's favorite positions were. I must admit that the presence of Val generally obliterates any of my usual thoughts of masturbation or even lovely blow-up dolls. Our attentions rapidly turned to each other, and we ended by standing up the blow-up couple on our first date, belatedly hoping we hadn't punctured their egos.

I had a nervous flight back, flashing on "Excuse me, Dr. Zarkoff, but we must insist on opening your luggage." When I finally got home, I wasted no time introducing Yoko to the soft pillows and blankets of my sexual laboratory. I removed her from her lurid cardboard container and spread her out on the bed. I stroked her flaccid plastic skin and flicked open the inflation valve on her back. Gently sucking the valve into my mouth and gripping it with my teeth, I slowly blew the breath of fullness, if not life, into Yoko.

Turning her body over in my hands, I examined her willing orifices. The gaping round mouth would have given Edvard Munch a raging woody. The cunt and asshole were anatomically indistinct.

I filled them with lube. Not being one who seeks out blow jobs from living partners, I passed on Yoko's mouth. Laying her on her back, I spread her legs and entered her polyester pussy.

Not bad...I moved my legs outside hers, a favorite position, grabbed her shoulders, and started humping away. Her mouth remained open wide, her eyes staring at the ceiling. "Pretty lifelike," I thought.

I turned her over and shoved myself into her prelubed asshole. All business, Yoko uttered nary a whimper at this assault on her nether parts. "Ahhh, much better," I thought. I really enjoyed the feel of her inflatable buttocks against my abs. It was a whole different sensation from lying on my back jacking off.

It was a little inconvenient, and I didn't dare consider the surreal absurdity of fucking a complex balloon, but it allowed me to get more of the feel of fucking than I ever would from vanilla masturbation. A few more strokes, and I was basking in the light of Yoko's perfect pink afterglow.

Fur

Susan St. Aubin

The cat started it by inserting her leg between Jon and me in bed, sometimes nosing down under the covers to sniff our crotches, sometimes settling between us curled in a white ball, her own nose to her own tail. I called her Ping because of the high pitched bell she wore on her collar to warn away the birds.

"That bell doesn't make me feel safe," Jon once said. "Who knows what she's doing down there under the covers. She could eat me alive." He kept a water pistol beside the bed, squirting between the sheets at Ping when he wanted her out.

"You're paranoid," I had told him.

This morning I lay in bed while the cat humped around under the covers, her bell giving an occasional muffled ring. Her bushy white tail passed between my legs in a caress so delicate I shivered.

Jon was getting dressed for work. I, who had an hour before I had to get up, pretended to be asleep when he kissed me and tip-toed our the door. I felt Ping's wet nose rubbing against my leg while the tail made another pass across my crotch.

I wondered about training cats. Experts in animal behavior say you can't: they say cats are too independent— or too stupid, opinions vary—to ever do what they're told. I

was certain my cat was smarter than most. I taught Ping to fetch by throwing a champagne cork across the room and, when she bounced after it, calling her name until she came back with the cork in her mouth to be petted and praised. Now she didn't need to be called because the sight of any cork caught her attention as a bird would: with a leap she'd grab it off the kitchen counter, the table, or even, on one occasion, out of Jon's hand to drop it at my feet and stare at me until I threw it. I thought if Ping could be trained to fetch corks, she could be trained to do anything. With a smile I put my hand under the covers to reward that seductive movement of my cat's tail

"Good kitty," I murmured, but Ping avoided my hand, sliding out the side of the bed and leaping on top of my dresser, where she began to lick herself.

"Bad kitty," I muttered, and then, in a soft voice I called, "Here Ping; come back, kitty, kitty."

Ping ignored me. I reached under the bed and came up with a dusty cork that I threw to Ping. When it hit the side of the dresser, the cat stopped to look down at it, then at me, before resuming her grooming.

With a groan I got out of bed and approached the dresser, but Ping jumped off and ran out the bedroom door, her bushy white tail lingering around the edge of the door frame before disappearing after the rest of her.

I sighed, then opened the bottom drawer and rummaged until I found a fur muff, real mink, that I'd bought at a flea market for five dollars. I wanted to keep it in memory of all minks who gave their lives for fashionable warmth, and now it rested in a drawer of silk scarves and wool sweaters, protected by blocks of cedar wood. This was my animal drawer: lamb's wool, merino wool (I thought that was goats), angora, worm-spun silk, and mink. I left the drawer open to let the spirits enter the room, and took the mink back to bed with me. Who needs an uncooperative cat?

I thought. Why aren't they made into muffs and sweaters?

With one hand in the muff, I wobbled it across the sheet, but it looked more like a clumsy bear than a mink. I'd seen a picture of a group of them, sleek and agile, standing on their hind legs, their big eyes focused directly on the camera. I wondered if they were smaller than cats, perhaps even prey for cats. I slid the muff under the covers, passing it across my breasts and down my side, feeling its softness tingle on my skin. I imagined the fur taking root and growing over me, joining with the few light hairs on my arms, spreading to the line of fine fur down the center of my belly and the darker hair of my crotch and armpits, then cascading over my body until I was a furry being with a vicious snarl when disturbed. No cat would dare chase me. I rubbed the fur over my breasts again, making my nipples stand upright, then walked the muff down my body to my own brown fur and rested it there, slowly rocking the hand inside.

I was an animal mating with another, our fur joined in a shining mass, our tongues flicking out to kiss and lick each other's fur. My finger was a tongue that slid out of one furry animal to caress the mouth of the other, my finger-tongue sliding across the wet fur around its mouth before creeping inside to trace the sensitive flesh that was myself. I saw the animal I was and called its name: Otter, sleek and wet, swimming through the river, whiskers dripping, safe from all water-hating cats.

The tongue of the mink withdrew from the otter's mouth to lick its face, moving carefully around the nose and down the soft lips before entering the mouth again to glide into Otter's warm, pulsing throat. Mink and Otter flowed together under water until they were one animal, Otter, rising above the river bank, above the tree tops, then bending to dive deep into the water, down to the muddy bottom. Otter's snout scraped the river bed and her eyes

streamed with liquid mud until she rose again to clear water, up through duck weed and schools of small fish, catching two in her mouth, snap, snap. She savored their salty, scaly taste, then broke through at last to bright air, to lie wet and gleaming on the grassy bank and blink the water out of her eyes while she exhaled her musky breath.

I lay limp in bed resting the mink on my thighs while I listened to myself breath. Who else was breathing? The otter wanted to snarl and dive deep into the safe river again. I opened my eyes to meet the gaze of Ping, who sat on a pile of sweaters in the bottom drawer.

"Cat!" I shouted, grabbing the squirt gun from Jon's side of the bed. Ping didn't blink. I sat up and pointed the water gun directly at the cat, who scrunched deeper into sweaters, ducking her head. When I got out of bed and walked toward her, calling to her in a silky, wool-warm voice, holding the squirt gun behind my back, Ping leaped from the drawer and ran out of the room. My last view of her was that tail curled provocatively around the door post.

Mysterium Tremendum

Jane Handel

It is well past the witching hour and I am lying on my bed. My back is propped against a pile of pillows, and my eyes are focused on a television monitor that sits atop a small antique oak dresser opposite the foot of the bed. I am watching a black and white video.

In the video, a Chinese man of indeterminate age is sitting on a black leather couch. He is wearing black leather combat boots with white socks and black Lycra or Spandex bicycle shorts. Very slowly, he unties each of his boots, removes one and then the other. He removes the white socks. Then, completing the strip tease, he methodically peels off the skin-tight shorts. He is now clad only in a black leather g-string. His face is expressionless. Inscrutable is the word that pops into my mind.

The man in the video picks up a bottle of baby oil. He pours some in his hand and slowly begins to massage it into his skin; first he massages the chest and arms, then the thighs; he rubs it onto the black leather g-string, under his testicles, into the crack between his buttocks. I lie on my bed and watch his ritual ablutions, as he purposely massages the oil into the crevices of his lithe, sinewy body. I wonder at the pattern of random marks that are barely visible on his smooth, hairless skin. They are like mysterious hieroglyphics that tell a story I cannot decipher.

When every inch of skin is glistening with oil, he puts the bottle down and removes the g-string. I notice that all of his pubic hair has been shaved off. His erect penis looks immense. He will tell me later that the oil creates this illusionary effect.

Now, the man in the video picks up a tiny black leather strap and buckles it tightly around the base of his penis, causing his testicles to look as though they might burst from the congested blood. He picks up the bottle of oil again, pours some in his palm, and resumes rubbing. His movements continue to be slow, deliberate, and methodical, his face still an impassive mask. He strokes his hard, seemingly huge penis without emotion or pretense.

He shifts his body so that he is now sprawled in a more comfortable position on the black leather couch. Staring directly into the eye of the camera, he rubs and strokes his penis. Sometimes he caresses his buttocks and anus. Every so often, he rubs more oil on his chest and pinches his nipples. But for the most part he concentrates on his genitals.

I watch him arch and stretch his back. I study the expression of both concentrated focus and wanton abandon. He is intent on what he is doing. And I am intently watching him do it.

His fingers wrap tightly around the shaft of his penis and his hand begins to move up and down, slowly, and then more rapidly. The only sound in this video comes from the music.

Sometimes, a murmur of masculine voices emanates from another room in my house. The sound reminds me that the man I am watching in the video is also sitting at my kitchen table—drinking tequila, smoking cigarettes, and talking in a low murmur with another man. He has brought me this video as a "hostess gift." Or consolation prize, depending on how I choose to interpret it. For a moment I

ponder this scenario and chuckle to myself. I am intrigued: why has he given me this gift? Why does he want me to observe him in this context?

As I watch his image I am reminded of Lord Shiva—the self-contained Hindu god of all dualities: male and female, light and dark, creation and destruction. I see before me Lord Shiva worshipping the sacred lingam he holds in his hand like a fiery column of light.

These lofty metaphysical thoughts dissolve as the hypnotic stroking movements—the intensity of his effort—arouse my body. As I slip my hand beneath the loose fabric of my pants and feel the wetness between the labia, my fingers seek my clitoris and begin a syncopated rhythmic movement which echoes that of the hand in the video. I am watching a man bring himself to climax in this video and at the same time hearing the sound of his voice from my kitchen.

As I watch the white sticky sperm shoot from the end of his penis onto his chest and stomach, I too bring myself to climax.

There are more videos, but they are all variations on the same theme. Aside from the first one, my favorite is of this man standing in front of a mirror, masturbating to his reflection. Aesthetically, the dual image of the Chinese man with smooth silky skin glowing with the lustre of baby oil, his lithe sinewy body taut from the intensified effort of jerking himself off, is very appealing. I lie on my bed watching and do the same.

At one point, while I am discreetly resting and no longer have my hand between my legs, he bursts in from the kitchen. For a moment, we both look at the video together. We both watch the man with the impassive gaze, the man who stares directly into the eye of the camera while fervently stroking his penis up and down. Then, the man standing beside my bed says in an exasperated tone, "Oh, are you

still watching this? You're such a whore!"

Turning on his heel, he scurries back to the kitchen where he will continue his conversation into the wee hours of the morning.

I ponder his comment with amusement but continue to watch his video. I am mesmerized by the way he rubs oil into his skin and strokes his penis up and down.

Eventually, I lose count of his orgasms.

How Can You Tell When You're Done?

W.F. Higgins

Early in my twelfth year, on a long car ride from Canada—without my mother—my father laid out the mechanics of sex in a grotesquely puerile rendition so replete with tinklers and te-te's and pee-pee that it seemed more a reprise of toilet training than an introduction to any adult activity. And the family doctor, to whom I was referred, provided a counterpoint virtuoso monologue of technical mystifications that dropped below four-syllable terms only when recourse to prepositions was unavoidable.

Yet despite the adult conspiracy's efforts to obscure the issue, to render it trivial or arcane, two days before my thirteenth birthday, I made myself come.

I had two long pillows in my room, covered in dark brown corduroy, squarish cylinders the length of my body minus the legs. They formed the backrest, converting my bed into a couch. For years I'd been dressing them in my pants and shirts and fighting them: punching, shooting, stabbing. Lately I had begun to make them female, cinching my belts tight around their waists and stuffing balled socks into the shirts. I had begun to notice the nude women on our neighbor's gameroom calendar, and to visualize the

varied similarities of flesh under the clothes of actual women. Also, I had become excited over a story in a space comic. In it, a man and a woman steal a treasure from hideous aliens. Having safely escaped in their ship, they embrace and, in the midst of a kiss, the man stabs the woman to death. But she has kissed him with poison lipstick and he dies in delirium a few seconds later. The ship goes endlessly on, carrying the two bodies and the universe's greatest treasure. I read the story over and over and would act it out, among fantasies of my own, with the pillow dressed as much like the woman as I could manage. When my erection rose, it was the obvious action to rub against the pillow. Over the course of a few evenings a peculiar tension developed, grew, and ultimately resolved in its inevitable—but to me most unexpectedly alarming— conclusion.

Knowing I was losing fluid, I was sure I had broken something and leaped up, still ejaculating, and ran to the bathroom at the head of the stairs, possessed by the need for the drain. My mother and aunt were standing in the front vestibule at the foot of the stairs and glanced up as I bolted into the bathroom, but even in my agitation, I knew they were incapable of registering what they saw. I got the light on and saw that the fluid was neither blood nor black, as I had imagined it in the dimness of my room, but a calming translucent pearl. I smelled it, caught a hint of sea and tasted its salt, the tang bringing the thought: "Well, I'm a man now," and, as a kind of footnote, in the tone of the Kinsey I'd perused at the neighbors' house a month before: "achieved climax before the thirteenth birthday." Finally I knew the answer to the one question that had remained unaskable after my father and the brusque family doctor had provided me with their distinct, but similarly unfelt, ball-and socket descriptions of the sex act: How can you tell when you're done?

Preparing for The Big One

Molly K. Flanagan

I grew up in a very strict Irish Catholic family. My mother told me proudly that she was a virgin when she married my father, and I was horrified to find out that she'd never even french-kissed before being engaged. A small town beauty who kept her admirers at arm's length, my mother raised me, her only child, to be "a good girl." I occasionally tried to fulfill her wish for me, but I did so halfheartedly, because from an early age I knew I wasn't destined for good-girlhood. My Mom told me frequently that sex before marriage was a sin, and she told me never to touch myself "down there." Nevertheless, when I was alone, masturbation was a frequent and favorite pastime.

I acquired my first masturbatory appliance when I was in second grade, at my school's spring fling. Called a Frustration Pencil, it was a pencil with a piece of brightly-colored fake fur glued to the eraser and little plastic eyes that moved when you shook it. The idea was that when you got frustrated you could roll the pencil back and forth between your palms; the fur would get all crazy-looking, and you'd feel better. Well, my Frustration Pencil sure made me feel better. It gave me my first orgasms and was my trusty bedtime companion—much loved (and loved and loved)—until the fur got matted and had bald spots and I

had to buy another. Luckily, they were cheap and all the rage, so I had a supply as long as I wanted them. I was always careful not to rub myself with the side that had the eyes.

In fourth and fifth grade I spent many nights furtively reading Masters and Johnson, and *The Kinsey Report* by flashlight under my covers. I could get turned on by reading almost anything. I discovered a real panty-drencher in *The Sheik,* a book that came out in the 1920s—it marked the beginning of my combining fantasy with masturbation (abductions and harem themes dominated for awhile). Sometimes I would masturbate in the cellar laundry room, in one hand a romantic novel with favorite most-explicit passages highlighted, the other hand working languorously on my clitoris. I was always on red alert during these times—my ears tuned to footsteps overhead, trying to hear over the spin cycle if Mom or Dad might be coming down to talk to me about my homework.

In the summer between fifth and sixth grade I rigged up my first vibrator—an old electric toothbrush with the toothbrush attachment taken off, wrapped in a washcloth. At that time I didn't know there were actually machines designed for masturbating. The first time I tried it I wanted to jump for joy and scream "Eureka," telling the world of my discovery, but that thought soon evaporated. I took solace in having orgasm after orgasm...it was a blissful time with my first vibrator, but our days together were numbered.

Mom first found my toothbrush vibrator while changing my sheets. She came downstairs with my love tool in her hand to where I was watching TV, and asked me why it was under my pillow. I told her that turning it on helped me get to sleep, and, much to my surprise, she appeared to believe me, because when I went upstairs it was back under my pillow.

Unfortunately, the second time Mom found the vibrator, I was using it. I was seated in a patch of sunlight in the middle of my bedroom floor, and the door was closed. I was fast reaching the point of orgasmic inevitability when Mom opened the door and saw me in all my glory. She screamed hysterically and kept right on screaming as she ran down two flights of stairs to the basement where Dad was in his den. Although I knew she was overreacting (by this time I knew from reading Kinsey that masturbation was healthy and normal), that didn't diminish the deep shame I felt. I was certain that my Mom now knew that I'd never be the good girl she wanted me to be. I wanted to die. After some time Dad came up and confirmed what the right half of my brain had been telling me—that masturbation is okay and normal. The worst part of it all (second only to being discovered), was that sometime in the next few days Mom took my toothbrush vibrator away. Oh, sorrow. I didn't find it again for more than ten years, after Mom had died.

In college when a boyfriend broke up with me, I bought my first "real" vibrator, at the Pussycat Boutique in New York City. I was amazed that first evening to come in only three minutes—soon I would be able to orgasm in under one minute. But occasionally I liked to take my time—to light candles and put on music as I would for a lover, and spend a grand total of ten or fifteen minutes before reaching orgasm. That first battery-operated vibrator lasted eight years—it got noisier and weaker as it got older, but it was an old friend, and I was sad to retire it not long ago.

These days I usually use a Hitachi Magic Wand to masturbate, sometimes with a dildo at the same time. My favorite dildo is a cheapo anatomically-correct rubber model. Using a dildo with my Wand is a sure-fire way to a fast and very intense orgasm. Once in a while, when I am feeling very ambitious, I put my Wand against the base of

my dildo and hold it there with my feet, while I use another vibrator, or just my fingers, on my clitoris. For some weeks I had a mirror over my bed and seeing myself in this position amused me greatly. I rediscovered how nicely laughter and orgasms go together.

So that I don't lose my "low tech touch," I regularly do what I call "earthquake-preparedness drills," by making myself come using only my hand, just in case my house loses power in a natural disaster. We Californians have to be prepared for The Big One; others store canned goods and blankets, and I do my part by having my drills. Perhaps I'm a fatalist, but I don't worry too much about those things. If I have to go, I can't think of a better way, my fingers or my Wand on my clitoris, having just had my own Big One.

Breadfruit

William Sash

Sitting at one of the open tables in the L'Auberge bar on the Front de Mer, I sipped hard French coffee and watched the ferry cross over to Moorea. The *Aremiti II* crosses every hour or so, and I took the noon shuttle out of Papeete Harbor. I'd never seen the color blue before crossing these Polynesian waters.

The heat of the tropics makes all but the most essential activities useless, and in the South Seas a strange transformation takes place. Attitude dissolves away and so does inhibition. Too much effort! These thoughts came to mind as the ferry pulled into the dock.

I stepped off the boat on wobbly legs and found my way to Albert's Inn. The caretaker pointed down a small hillside. Around the buildings were several small and mid-sized trees, the likes of which I had never seen. I went down to the bungalow marked "21," entered through the open screen door, and collapsed at the kitchen table.

Sitting on a short wooden stool, and guzzling my last bottle of Eau Royale, I unbuttoned my sweat-soaked shirt. There was a knock at the door. A young bronzed woman wearing shorts and a thin white t-shirt stood in the doorway with a basket of fruit. I invited her to sit down. Her face was a mask that hid years of Polynesian grandeur and mystery. Her eyes gleamed tirelessly as she opened a mango with a

small knife. The pulp oozed out and ran down her forearm, mingling with beads of sweat. I looked at an unusually large and segmented fruit. "Breadfruit," she said, smiling.

Oh, so *this* is breadfruit! The famed fruit of Captain Bligh, Fletcher Christian, and the good ship *Bounty*.

"How do I know when it is ripe?"

"When it is yellow. It's ripe now."

She left me alone in my kitchen. I grabbed a lemon, warm from the sun and bit into it. I don't know why. Reason had left me. It tasted sweet and not at all tart. I wondered what people would think of me back home. A person is not supposed to bite a lemon! Well, there are lots of things we are not supposed to do, at least not in public. But I am far away from all I know. I squeezed some of the juice onto a slice of French bread and ate a big chunk. A piece fell into my lap. I picked it up, and noticed that I was feeling a little aroused. I gave my crotch a small squeeze. A flush of blood rushed through me, and I breathed deeply. My heart quickened. I stared at the odd looking breadfruit. So strange, so alive, and ripe. How do you eat this thing? Grabbing the bumpy skin, I ripped a small lump out and tasted the meat. Hmm, interesting. Tropical. Different. Certainly not Sunkist. The hole I had made in the side of the fruit was almost speaking to me. I picked up the fruit and stuck my tongue into the crevice. Extending my tongue as far as I could reach, I sucked in the grainy juices. This is crazy, I thought. I was getting turned on, and I began to feel wild. Wild is what I wanted, and with shaking fingers, I undid the buttons on my shorts and lifted my penis and balls out of my underwear and into the afternoon air. Grateful for its new freedom, my cock swelled with each rush of blood. I stared, mesmerized by its growth and the rising veins filled with life. To a man, his penis is at once an object and a subject. It is something personal, and something mysterious. It is himself.

Aware of the danger of discovery, in a crazed exhibitionist state, and almost hoping for an audience, I proceeded to masturbate furiously. Ah,' the pleasure, as I rubbed breadfruit juice into the shaft of my cock. My cock lifted its head with triumphant pride. With my left hand I rubbed my chest, then grabbed my loose balls and tickled the little hairs below.

The feelings of power and the surprise of pleasure were tremendous. The breadfruit seemed to be breathing and calling to me. I picked up the dripping carcass with both hands and impaled it on my penis. The hole was too small. Grinding and tearing, I made love to this ripe breadfruit for several delicious moments. Making great thrusts, lifting my buttocks off of the stool, I could feel the steam rising. My seed was boiling, and I took deep breaths to delay the impending ecstasy. A running start, a gallop, a thrust, a leap into the unknown space. Wave upon wave of shudders rippled through my body. I came, thought I had come, and I came again. My legs gave out and I collapsed back onto the stool; a thin white line of ecstasy dripped down the side of the warm fruit. As my throbbing subsided, I lifted the breadfruit to my mouth and sucked out the semen. Swallowing the sweet warm and tangy come mixed with bits of fruit was intoxicating, and I nearly blacked out. Smiling, I lay back in a heap, wet and satiated. I took another bite of the lemon.

Magic

Kent Johns

I am forty years old and have been masturbating since I was about ten. After nearly thirty years of "doing it" by hand, I got a Hitachi Magic Wand. I first tried a cheap (pointy) vibrator a couple of years ago. But the battery powered gizmo didn't do anything for me. So I thought all vibes were useless—wrong.

I went shopping for a vibrator, determined to try a plug-in, and was lucky to find a Magic Wand on sale. I was a little embarrassed waiting in the store's check-out line with the vibrator tucked under my arm. Some women in line noticed the box; they looked at me and smiled. I think they knew what I'd be doing as soon as I got home.

I love my Magic Wand. Since I bought it a year ago, my self-pleasuring ways have been changed forever. The vibe rekindled my desire to masturbate. Simply put, I can't put it down.

I still remember my first time using the wand. I gently placed the foam head on my knob and flipped the switch on. "Ohmigod! I was hard in a heartbeat. My body trembled from head to toe with anticipation.

I still enjoy hand-jobs, but I use the wand a lot. It is an easy way to have an orgasm. I keep it at my bedside and use it nearly every morning. Masturbating with the wand has become part of my wake-up routine.

A few months after getting the vibe, I bought a Come Cup. Slipping on the vibrating cup is pure ecstasy. If I prop the vibe on my thigh, the cup leaves my hands free to roam and caress. Initially, my glans was too sensitive to use the cup. The intense vibes hindered my orgasms. But I no longer have that problem.

For years I felt so ashamed after masturbating that I wanted to stop doing it. Now I realize masturbating is okay, and I do it frequently with great pleasure.

Self-Abuse (More, More)

Juliette Vargas

I wasn't actually masturbating. And it's a good thing too, because that was something I had been told was disgusting—it was "self abuse." I was merely fantasizing, fueled by those Christian novels in which the young girl runs away from home, becomes a prostitute and drug addict, and in the last chapter finds God. I'd skim that chapter in case anyone asked. And I was having what I had read during my ongoing research was called a "pleasurable discharge." See, I wasn't penetrating myself and since one could only have an orgasm during the act of vaginal intercourse, I wasn't having several orgasms a day, but was in fact experiencing the aforementioned discharge which sometimes accompanies touch prior to intercourse. Besides, one apparently had to use her hand to masturbate, and I would purposefully use any wadded up sheet, towel or pillow instead. Except for being worried that something was wrong with me because my favorite sensation was located a bit higher up than that mystery hole, I was in the clear. Still, nothing could stop the waves of guilt that inevitably arrived as soon as the passion subsided.

By the time I was in my early teens I knew what I was doing. I began sliding the tell-tale hand between my legs, but now I had a rationale to justify my actions. I had seen a film where some guy talked to teenagers and their parents

about adolescence and insinuated that it was okay for boys to masturbate occasionally because it functioned as a release which allowed them to stay out of "trouble." It was not the only time I was to hear this rationale. Adults who had seen the film praised it, except for the narrator's quasi-acceptance of masturbation, and while I disliked the film overall, I was thankful for any excuse which I could repeat to myself when I was distressed about my habit. I figured the guy knew more than the adults in my life did (I mean he was the one in the film, right?), so I lumped myself in with the boys. I could consider all that pleasure to be a preventive measure.

I had done my research about birth control and figured that even if I used two or three methods, those failure percentages could all line up simultaneously. As far as I was concerned, possible pregnancy was not an acceptable option.

So I learned to have sex with boys without the penis/vagina contact. Masturbation, both alone and with my partner, became crucial. In a sense, everything related to what I did with myself. Not only did it mean that I knew about my body and touch, but for example, that my initial choice of lingerie was based on whether I could come from looking at myself wearing it.

Almost all my friends were boys. They made jack-off jokes freely and frequently, so it seemed to me that my behavior was "normal" enough. Yet the few girls I knew well only joked about masturbation in reference to males, never females. When I mentioned the subject they adamantly denied doing it. Much to my distress, the girl I was closest to claimed that if she touched herself like that she wouldn't ever be able to look at herself in the mirror again. Of course, when I was on the spot, I denied ever making myself come too. But in private, behind the locked doors of my bedroom and the bathroom, and, increasingly, in other places (such

as in sleeping bags at my friends' houses), I continued to go at it. My masturbation gradually moved away from an act to accompany a fantasy and began to include recognition and enjoyment of the sensations themselves.

I shared a room for the first time when I first went to college. I desperately feared being discovered by my roommate, so I took precautions. I only did it when I knew for sure that she'd be gone for a while. I locked and constantly checked the door. I even came up with elaborate tales of how I could explain myself and my position if she were to return unexpectedly. Even though my internal guilt was steadily diminishing, I never did become comfortable with the idea of my roommate finding out, nor did it occur to me that she might be doing the same.

Later when I had more privacy, my more elaborate and time-consuming self-love sessions returned and expanded in motivation and technique. I was given my first dildo as a gift from a long-term partner. I started reading porn novels as well (those cheap paperbacks with the stupid titles). Some of the porn, read with one-handed enthusiasm, was made more interesting by the fact that it was written by my friend and housemate. This was reassuring and improved my self-image—if someone I liked and respected was actually writing the stuff, then maybe I wasn't so warped for seeking it out, despite what was said in my Women's Studies class.

It took a few years, throughout which my own activities and self-knowledge expanded, until I found women similar to me and I found books which validated, enhanced, inspired, and interested me, and made me wet.

Now I easily distinguish between the kinds of masturbation I use for different purposes. There's the quick fun with porn spread out around me and the vibrator humming away at top speed, the claiming of territory and consoling when my partner leaves the house for a few days, the

reinforcing of identity, self-worth, survival when I first check in to another strange hotel for a job I hate, the reveling in being "nasty," the enjoyment of being watched, the extended purposeful exploring of fantasies, and the slow gentle soothing—to mention just a few. Yet they all have the same element at the core. That is an affirmation of me and my well-being.

Triptych

Nancy Irwin

CORN

It was my first solo canoe trip, three days, of which only one would be a full day alone in the wild. I've canoe-tripped alone before, but had only done day trips. I was looking forward to the experience of being by myself in the woods, breathing in Mother Nature, swimming, paddling and cooking on my own.

Normally when one goes canoe-tripping, one has survival in mind. Certain luxuries are left behind in the kitchen. Granola bars, dried fruit and instant powdered food are the diet. But I try to avoid camping like that. I had brought things with me that no camp counselor would allow: apples, bananas, blueberries and raspberries...and fresh corn on the cob.

I rose with the sun after my first night out, crawled from my tent and put a few clothes on till the place heated up. I was surrounded by trees on one side and water on the other, sitting on a huge boulder that rose from the water and disappeared into the earth. The forest smelled great. I set my camp stove on the rock slab and prepared my first decadence: a nice stiff cup of black tea with milk and honey. I sipped my tea and wandered around the forest until it was warm enough to take off my clothes. I picked up a sack full of fruit, went down to the water, slid my canoe back in, and

prepared to push off.

I got to spend the entire day naked in my canoe. A light breeze tickled the hairs on my arms and legs; the hot sun beat down on my shoulders and reflected off the water. It made me feel high. When it got to be too much, I simply went ashore at some little beach, got out, and went for a swim. The cool water caressed my skin. Swimming without clothing is a very sensual experience.

I did come across a few people during that day, and I considered going for my clothes. But, people who are out canoe-tripping to "get away from it all," are in couples or groups of four, and generally keep to themselves, other than to wave or say hello in passing. And they often have few clothes on themselves.

I did, however, encounter a group of Boy Scouts, six canoes with three pubescent boys or counselors in each. I considered pulling on a shirt or shorts, but decided against it, and let the group approach me head on. To my amazement, none of the boys spoke. They stared at me until we got close, and then, as if on cue, every one of them turned his head to look away. I had to laugh, but I waited until they had passed me. I guess there is power in being naked after all.

I went back to my campsite about mid-afternoon. I was hungry, and got the food out. I love corn, and this cob I'd brought was from the first crop of the season. It was wrapped in green, which I peeled back to reveal perfectly formed yellow kernels on a beautifully shaped cob. I found myself sitting on the rock, warmed by the sun, my knees spread and a cob of freshly peeled corn in my hand.

I began to rub it on my crotch. Soon, my cunt was getting wet—and wide. I pushed the cob end around my clit, rubbing it side to side. There I was, on my knees, on a rock, looking out at the water and hoping a canoeist or group of Boy Scouts didn't happen by, with a cob of corn plunging in

and out of my pussy, feeling great (and a bit peculiar). Watched by the trees, my sounds blending with the birds, I came all over that cob of corn, filling the cracks between the kernels with my juices.

Guess what I had for dinner?

TRIUMPH

I discovered the vibration the first time I rode a British bike—everyone does. But I didn't discover the raised chrome strip that runs over the gas tank straight to my clit until I rode with the dyke contingent in 1982, in my first Lesbian and Gay Day Parade.

There we were, twelve of us, baking in the hot sun, grinning ear to ear as the crowd cheered us on. We were celebrities, every one of us. A sense of pride and community washed over me.

I felt a tingling between my legs. I looked around at all the beautiful women (and men) in the crowd, all scantily clad, all excited. Sex filled the air. Round firm girl tits in tiny halters; naked flat boy chests with hard little nipples, short shorts and even shorter shorts...all these surrounded me, and the next thing I knew, I was getting wet shorts myself.

I looked down at my crotch, imagining a big wet gush showing through the fabric of my crotch, but I was relieved to find that I didn't look as wet as I felt. We rode block to block, stopping for the parade of screaming queers to catch up. And as it idled, my Triumph just kept vibrating, making that sweet music only a Triumph can.

Then something happened. I "accidentally" pushed my clit up against the gas tank, which was vibrating at a rate of 1500 revolutions per minute—and at that moment, smack in the middle of the parade with commotion all around me, I discovered the chrome strip on my "British Vibrator."

This was a fantastic discovery! I rubbed my clit back and forth across the strip, which created a little bump about a quarter-inch high dead in the center of my clit. In no time I was lost to the world, girl juice gushing between my legs, having orgasm after orgasm. It was a wonderful parade.

I've ridden a lot of different bikes and a lot of miles since then. But when anyone asks which is my favorite and why, I smile and say, "the British Vibrator rules!"

CHINA VIBE

I was traveling in China with a small backpack, carrying the bare essentials. My plug-in Hitachi is not only large and heavy, but requires a different current and plug than those available in China. I'd learned from past experience that vibrators with two or three "C" cell batteries weigh quite a bit; even silicone dildos are heavy. So there I was, traveling without.

It was just before the Chinese New Year, some time in February. My girlfriend and I entered a large store resembling an American department store. We were shopping for silk long johns that sell for thirty-five dollars per piece back home; we'd seen them here for five dollars a set. But as is common in China, one can find either the bottoms or the tops, but not both at the same time. So we loaded up with tops for ourselves and to give as gifts. The woman at the counter was quite surprised at the money we dropped on silk—so expensive.

Suddenly we saw a whole group of attractive girls demonstrating a new product—just like at home. Only it wasn't perfume, a vegetable chopper or some other household gadget they were selling. For about seven U.S. dollars we could buy our own personal body "massager." These girls were running cute white palm-sized vibrators all over their bodies. We rolled our eyes at each other, then started laughing. The girls giggled too. To their amazement

we purchased two of their "massagers."

Back at the hostel, we were anxious to be reminded of what a vibrator felt like—it had been weeks since we'd left ours behind. But we had a small problem; we were sharing a sleeping room with eight other women. Still, it was only six p.m., and for a moment we were alone in the room. We turned the vibrators on to see how loud they were.

Hours later, I was in my bunk, vibrator in hand, hoping the other women couldn't hear the buzzing on my clit. Four "AA" batteries are a far cry from a Hitachi Magic Wand, but after weeks of deprivation, the little buzzer felt great.

I came, lying there in a room full of not necessarily sleeping women. A sound startled me as it escaped my mouth. I quickly coughed, trying to turn my orgasmic groan into something else.

I heard a muffled chuckle from the lower bunk two beds down.

Songs To Myself

Daphne Slade

The following are observations that I found scattered through the journals I've kept for the last nine or ten years. That empty quiet space after masturbating often beckons me to fill it with words. Since a lover is usually not present, I find myself talking directly to or about my orgasms. Being alone allows me to concentrate on my unique experience. Still, I always wonder if these observations have resonance for others.

When I masturbate, I wonder why I would ever want to share such a private experience with anyone else....

Some orgasms start one place and end elsewhere. It's like falling asleep on a plane and waking up in another city. I can't figure out how I got there.

I like to watch my feet when I'm aroused. They arch like perfect high-divers.

Beads of sweat appear on the face of each toe. The closer I am to coming, the more my toes take off. Right before I climax, my toes quiver every which way, helter skelter. Then I come. I can feel the current traveling down my legs through my feet which stretch and stiffen as if shot.

Periodically, I lose something and frantically search my apartment only to realize that what is missing is right in my hand. Some orgasms are like this.

The orgasm is a phantom caller ringing my doorbell. I must answer at just the right moment. If I wait too long, it will give up and leave, but if I answer too eagerly, I could startle it, and it will flee.

Some orgasms confuse me. I don't know who's in control. It's as if I were walking a big powerful dog. Who's walking whom?

If I masturbate when I'm depressed, it's like making love to someone and realizing that I no longer love him.

Occasionally I have a "subtle orgasm." Was it just the urge to urinate, or was it the real thing?

Once in a while, I have "long-distance" orgasms that I feel most intensely outside my clitoris, perhaps in an arm or a leg.

I have a recurring fantasy. I am in a huge Greek amphitheatre. The audience of thousands includes everyone I have ever met in my life. I am in the center of the stage lying naked on an elaborately decorated table. It is laid with the finest floral-embroidered white linen. Gorgeous, fresh-cut pale pink roses are strewn over the huge, sunken stage. A man who looks like a symphony conductor, dressed in a tuxedo, is performing cunnilingus on me while the audience, mesmerized, waits for me to come.

I imagine taking my vibrator out on a date. First, I'd take it out for an elegant romantic dinner, placing it across from me in candlelight at Restaurante Phillipe. Then, I'd park on Lover's Lane and get into the back seat of my car with it.

My mound is a frisky little dog begging and jumping way up into the air, pleading for its master to throw some food into its hungry mouth.

Sometimes I've worked so hard achieving orgasm that I feel, at the very least, I should be paid minimum wage.

At the end of a series of multiple orgasms, if I don't know when to quit, I get to "the old matchbook syndrome."

I strike the match against the worn out matchbook again and again, but it's useless.

My orgasms are like waves breaking against the shore, one after the other. Then, quiet pools. Perhaps a few ripples. Maybe an indecisive wave that folds into itself.

I lie in bed suffering from post-orgasmic stress syndrome, longing for earthquakes, breaking into a cold sweat whenever I hear anything faintly sounding like a vibrator, and feeling that nothing is ever enough.

Sometimes, when I know I am going to come, I briefly hold my orgasm like a handful of water before letting it fall through my fingers.

Some orgasms take off before I am ready; they are not team players. I have to shout at such orgasms like Dorothy in the *Wizard of Oz* cried out to the hot air-balloon taking off without her: "Wait, wait, come back. Please don't leave without me."

Some of my orgasms remind me of Tinkerbell. They leap out of my body sprinkling me with fairy dust.

January 17, 1962, 8:05 PM

Caprice

I was seven years old when I first learned about masturbation. At the time, it seemed like an incredible gift that was mine alone (now I look at seven-year-olds and wonder if....).

That fateful evening I had had some friends over to play, and had just walked them to the corner as they went home. It was January, but California winters are not cold. On the way back to my house, I continued the game that I had been playing with my friends, running from tree to telephone pole, hiding behind each one—just being a kid.

When I got to our front lawn, I dropped onto my belly to crawl to the front door. At this moment, Fate intervened. Instead of being in its usual "dress to the left" position, my dick had worked its way to a straight up and down position, and now it was getting rubbed as I inched along on my belly. Suddenly, my body was filled with pleasure, the likes of which I had never known. It was immediate, and compelling. All thoughts of the game I had been playing were banished by this fantastic sensation. I stopped crawling and rocked back and forth over my cock, absorbed in the new feelings.

I lay there in the cool California night, consumed with pleasure—illicit, private, and very good. Soon I heard footsteps approaching—a woman was walking up the

sidewalk across the street.

Although I had no idea what I was doing, I felt the pleasure building in me, and I pursued it with diligence and concentration. I wouldn't have stopped for anything. As I approached orgasm for the first time in my life, I watched the woman walk by. I was unwilling, in fact unable, to stop just because there was a risk of being seen by a strange adult. I came just as she turned the corner.

After basking in the afterglow for a few minutes, I struggled to my feet and went into the house. At seven, I had absolutely no understanding of what had just happened to me. But I walked through the house with minimal greetings to my family, went to my room and tried this new thing again. It worked. Twice. I remember thinking that life would be better from then on—that I had something that was mine alone, something to lift the dreariness of life.

And it did, and does.

Fucking With Your Selves

D. Travers Scott

I want a sex partner who's willing to do all the things with me I'm willing to do with myself." Tom said this once in casual chatter, just part of our idle cruising soundtrack. the words itched in my head all night, long after he'd left me for a redheaded sign language interpreter in his '66 Nash Rambler.

At work, Tom would explain his masturbation rituals with relish. Tom, the huge-dicked, golden goat-boy with electric-blue eyes and a fiendish grin. He stopped daddy-bears and prissy clubfags (not to mention most women) equally dead in their tracks. He could easily get someone to milk his meat morning, noon, and night, and never have to resort to jerking off.

But jerking off wasn't a last resort to Tom. He conjured up an entire environment for his masturbation. He burned copal, ambergris and pitch he'd collected in Sedona. He propped a broken mirror shard against the base of a bookshelf to view his ass, watch it spread and engulf the eleven-inch foreskinned dildo. He blasted Cocteau Twins, Terrace of Memories or some other ambient music he could trip out on. He drank wine or a good microbrew. He took herbal tinctures, mugwort tea or smoked a joint to help himself slip into a trance. He strewed the thin Karastan rug he got from his first boyfriend with thrift-store velvets, satins,

silks, curtains, bedspreads, jock straps, lingerie.

And he fucked himself silly. The rubber cocks got fatter, longer; the vibrators more geometric and alien. The titclamps, the stiletto heels, the vacuum-pump, the plastic cord. The rug burns, the strained neck, the bruise under the left eye. "No grapefruit juice, thanks, I bit my tongue really bad last night."

As we dished in our computer cubes during break one day, I found myself hiding my jealousy in furtive sips of double-skinny-mocha-cappuccino. Jealousy or shame? Tom never said, "Don't try this at home"—I easily could have, nothing was stopping me.

I thought about how, when I was in junior high and high school, I had never experienced a circle-jerk, or any of those other sexually-charged JO experiences I've heard so much about. For some reason, in my Reagan-era corner of Texas, masturbation was not something guys would admit to doing, much less do together. Not because it was taboo; it was considered something for losers who couldn't get a woman. We were amazed by scenes in movies like *Footloose* where guys casually acknowledged jerking off. It was something we mocked and never admitted.

Tom inspired me. The first time I jacked off alone and without porn (as an adult), I experienced a vivid childhood flashback: standing on my head, my fourteen-year-old skinny legs climbing the wall of my parents' bathroom, furiously yanking till a big maroon bruise spread across the right side of my cock.

It hadn't been traumatic—a week's rest and the bruise was gone. But remembering it brought back all the vigor of my adolescent masturbation. More importantly, I remembered the experimentation, the risk-taking, the adventure.

I'd forgotten about extremes initiating from within me. I usually imagine another person pushing my envelope, taking me to unexpected new limits. But Tom made me

think of myself in simultaneously-multiple terms: top *and* bottom, college-boy, Air Force cadet, trucker, rapist and raped, fluffy disco boy, surly sewer-mouth, punching bag, curious straight boy. All the roles I've played with others exist with equal validity within me. Tom's accoutrements all focused him inward; mine focused me outward. Instead of depending on someone else to validate and activate those personas, Tom created a sacred space in which he honored them all, allowed them to coexist and interact, explored and got to know them better. He redefined the concept of "alone" for me. Now, instead of a negative state defined by the absence of others, being alone is liberating. Alone, I am safe and free to enjoy the company of my selves.

Perhaps because I'm such an introvert most of the time, my sexual dialogue has been very externally focused. I still love my porn, fuckbuddies, and exhibitionism. But Tom helped open up a vast interior world to explore. Or perhaps I should say he brought me back full-circle to where it all began.

A somewhat different version of this contribution appears in *Black Sheets #6.*

Behind the Shower Door

Rowan Michaels

Some individuals discover their sexuality slowly and carefully, taking time to explore this new aspect of themselves with caution and delicacy. Not me. I never have been the slow or cautious type. I have always thought of myself as a bull in a china shop just looking for trouble and new things to get into.

I discovered exactly what my pussy was for when I was just twelve years old. I remember seeing a love scene between a man and a woman on a train. Enthralled, I felt what I could only compare to a sense of "itching" in my pants. I didn't find it odd for some reason that instead of wanting to be the woman, I wanted to *have* the woman who was getting fucked so deliciously in this PG-rated paradise of a movie. I didn't know quite what to make of these feelings and ended up in the only place in the house I ever really had any privacy, in the bathroom taking a shower.

Without realizing what I was doing I managed to maneuver the stream of water so that it ran over my budding chest and down between my legs. Surely I must have done this countless times before, but never before this moment had I ever had these sensations. I pressed myself as flat as I could against the shower walls and desperately tried to aim the water where it felt really good. After about twenty minutes or so of this angling, inspiration hit. If I lay

down in the basin of the shower the water would have time to build up more force and I could direct the flow to where it felt best! I didn't have a clue what to call that place, but I was suddenly achingly aware of its existence. Lying flat felt better, but it still wasn't enough. I didn't know what I was headed for, but I knew that I wanted these delicious sensations to go on and on. My breathing was ragged and my fingers anxious claws as I tried to force my body to cooperate with the teasing water pressure. The water grew steadily colder. I didn't care. The need to go on gave me no alternative and no options, there was absolutely no way I could stop.

I had another inspiration as I panted and climbed for that unknown peak. Perhaps if I tied the washcloth around the shower head, I could direct the flow of water into one hard jet that I could position myself under. The pressure was almost unmanageable at first; the ecstasy was so intense it left me gasping. With a sudden start I felt my body tense; then I was shaking and quivering, unable to bear one more second under the jet of water.

I left the shower feeling weak-kneed and confused, with no clue about what had just happened to me. The next day after school I dug out my father's stash of *Penthouse* magazines and began reading. The pictures gave me the same flushed feeling I had gotten from the movie. Feeling my body begin to hum, I stared more closely at the bodies splayed out in the glossy magazine pages. Looking at these bodies, I began to see a slight similarity to my own. I ran to the bathroom and got my mother's magnifying make-up mirror and began examining myself, looking eagerly for some sameness. My body began to change before my eyes during this self-examination; my nipples became rigid, my genitals turned pink, and I could see my clit (even though I wasn't sure what it was then) begin to harden. I stroked it gently and was rewarded with the same rush I had felt

in the shower. So *this* is what had given me such bliss!

Shortly, I began to experiment, looking for new and novel situations to bring on those crashing orgasms I had first experienced in the shower. In a frenzy to get more pressure I sat in the sink and aimed a jet of water onto my clit. This sent me off like a rocket, but also had the unfortunate side effect of spraying water all over the bathroom. My parents had also become a force to reckon with and were soon limiting my exposure to water (whether they figured out what I was doing I will probably never know).

Almost by accident I learned that it also felt good to slip things inside myself. I began with my own finger and then graduated to other things. The collection of pornography I had stolen from other places all indicated that women loved *big* things inside them and I worked persistently to fit bigger and bigger objects inside myself, looking for the ultimate "high." I stole and inserted a candle. A flashlight. A Coke bottle. Hot dogs. Cucumbers. I wanted anything and everything but nothing seemed to fit just right.

I then began my "alchemy" phase, looking for the perfect combination of sensations. I raided my parents bathroom cupboards and medicine shelves. I slathered shaving cream on my pussy. Then I tried cologne, perfume, baby powder and baby oil. Hand lotion. Face cream. Anything to get that part of me fired up and hot. I finally found that a small amount of cologne, mixed with shaving cream, gave me a stinging warm feeling that could, in combination with my own fingers, get me off deliciously.

My parents ended this small creative phase of my growing up period when they did the unthinkable. They came home one day with a so-called "massager." It was bright orange and had nubby bumps all over it. I hadn't a clue what to do with it until I felt it for the first time on my back. I was hooked. I was an instant electricity junkie and was bound and determined to try that damned thing the

very instant I was left alone with it. My chance finally came. After a solid week of fantasies about the forbidden item, my parents went to a movie, leaving me two full hours to explore the new toy. I went to the living room and perched rather precariously on the arm of the couch. While this felt extremely strange, it had certain advantages which I needed. I could look directly out the windows through the sheer curtains and tell instantly when my parents came home. Then I could be in my room reading nonchalantly before they even left the car. I turned the massager on and placed it on my clit. I will never forget the start my body gave as the first jolt ran through me. It was too much for me and I had to scheme and create ways that I could make it just a little less intense, never imagining that later I'd be begging for this very same intensity.

From that day on I used the vibrator at every opportunity, always on the arm of the living room sofa, always looking out towards the street. This created one more final part of me that lingers to this day, the part of me that is an exhibitionist. Although I am certain no one passing by outside would have been able to see me furiously masturbating even had they looked toward my window, this situation led to endless hours of fantasy and self-exploration with the notion that I was clearly visible. My exhibitionistic fantasy life was full and rich. Some days I thought about people from school walking by and seeing me; other times it was having someone report me to the police and having a uniformed officer (or two) come bursting through the door just as I was about to reach nirvana. These fantasies of being caught in the act never failed to get me off.

Now I suppose I'm a bit stodgy in my masturbation habits. I almost always do it in my room with my door closed, although I welcome the variety of doing it in different parts of the house when I know I won't actually be interrupted. I have my own "massagers" now and never

hesitate to use them, in addition to a wide variety of other toys I have acquired along the way. I have quite a nice selection of insertable objects and now I am finally able to do what the big girls do and take it, take them all. Sometimes, just for kicks, I'll lock myself in the bathroom, flip onto my back and inch my way down beneath the faucet of my tub. As the water runs down over me I let my mind wander back to younger days, when solo sex was riskier and so much more exciting. And sometimes, very rarely, in my mind I can hear my dad knocking on the bathroom door demanding that I hurry up. These days I choose whether or not I want to listen to him.

My Mother's Vibrator

Robert Morgan

T he family vibrator was kept in the hall closet along with the household linen and body care products. I remember it carefully packed in its own box, cord wrapped in a tight bow, with all the smooth clean white attachments in their appropriate spots. My sex-positive mother had acknowledged my right to pleasure myself, and had given me enough anatomical names to make me appear dangerous in the eyes of some of the more conservative parents.

I began to explore different ways of pleasuring myself. I tried the shower nozzle but it was too hard to climb up to, lubricants were fun but messy, and rubbing myself on the sheets was beginning to get painful. I was reading one of the "family health tracts" about marriage when I found an entry about "marital aids" which suggested that a wife might use a vibrator as an accessory to marriage when her husband was away. I wasn't a wife, but it got my attention so I decided to check it out anyway.

My first experience with a vibrator was almost absurd. I unwisely chose the front room of my mother's house to explore this new thing. I'd settled myself into my favorite reading chair and had just begun to apply the heavy, smooth, maniacally buzzing instrument when I heard whispers out in the front yard. I quickly pulled up my pants,

yanked the cord out of the wall, and retreated to the privacy of my own room. (Later my brother and his buddy would kid me about "putting that thing on you.") When I got to my room I stripped, lay on my bed in the warm, cotton-filtered sunlight, and tried the toy for the first time. It was probably the most intense thing that had happened to me before puberty. What a concept: 1) put vibrator against penis, 2) orgasm, 3) repeat until exhausted. (One day I came thirty-five times just to see how many were possible).

I spent hours with the vibrator, exploring what all of the different attachments were for, and finally settling on the wide flat head. I would stroke my shaft and thighs until I just couldn't stand it, then I would very slowly and carefully put the head against the tip of my penis and, holding very still, would bliss out until my asshole and pelvic muscles pulsed with joy and my body tightened in orgasm. My technique varied, but I used the same vibrator until I was about eleven.

One day my mother asked if I was using the vibrator. I felt immediate apprehension, as if I might have worn it out. When, in a small voice, I said that I had, she told me that in the future I would have to make sure I cleaned it thoroughly after using it or "face the consequences."

You see, I had just recently begun to ejaculate and in my hormonal haze, wasn't consistent about activities like cleaning and thinking. My first ejaculatory orgasm had surprised me. Along with the incredibly voluptuous feelings came a sudden sharp fleeting sensation of pain deep inside my urethra; it hurt and surprised me so much that I waited at least an hour and a half before trying it again. So it again came to pass that my level of fastidiousness dropped and I was confronted by Mother with a less than pristine vibrator. This time she made it clear that I was no longer to use hers.

She sent me on my bicycle the seven miles into town,

by myself, to the Rexall drug store to buy my own vibrator out of my paper route money. You can imagine my trepidation; I was still eleven years old. I had just enough sense to get into the store, keep my mouth shut, pay and get home. I settled quite nicely into my relationship with my new toy, and since then I have actually worn out a few of them.

Big Mama and the Superballs

Shannon René

T he panic was rising. The emergency room is going to love me—an eight-and-half months pregnant woman with two Superballs stuck up her ass. They wouldn't even be able to roll me over on my belly to get these things out.

You wouldn't believe how terribly horny you get when you're pregnant—or, at least how horny I got. The last four weeks I couldn't sleep without masturbating before going to bed, or the throbbing would kill me. I didn't care that I had gone from a petite size 6 to a 168-pound big "mama." On my way to work, I fantasized about doing entire construction teams. I'd kick my dog out of the bedroom at night because his licking sounds drove me crazy.

At first I masturbated my traditional way. My hubby worked evenings, and he didn't want me when I was pregnant anyway. So onto my belly I would go, and I'd grind away until I came. As time went by and I grew larger, I had to become more inventive. Oh, I had vibrators and dildos, all right, but they were off limits to me unless my husband was there to use them on me. He'd check to make sure I hadn't touched them while he was gone; I was never able to get them back into the drawer exactly the way he'd left them.

I finally figured out a way to have a little fun in the

shower with a couple of household implements. I regularly raided the kitchen and bathroom for things I could use: spoons, toothbrush holders, the turkey baster. This worked out fine for a while until I couldn't see what I was doing; after that, I'd have to take an old makeup mirror and place it on the shower floor. Ah, success. And what a sight. Under my large hanging Buddha belly, everything looked intact. I didn't realize how much I'd missed seeing those parts of my body until they slowly disappeared over the horizon.

Unfortunately, I could never quite come with just a dildo; I had to have hard pressure on my clit. I would run—well, waddle—out of the shower, hop on the bed, prop as many pillows as I could get my hands on under my pelvis, and finally, finally, be able to come. Hard work, but without it I couldn't sleep.

About two weeks before my son was due, I started to worry I might be playing too hard. Of course I wanted my child, but I was terrified of the birth process. I didn't want to rush labor by banging a dildo against my cervix. You have to remember that a woman eight months pregnant is not the most rational being in the world. I still had this insatiable drive. I finally decided that maybe anal fun would be the way to go. I could still get all those wonderful sensations without worrying about premature labor.

I found two Superballs—the kind you get for twenty-five cents out of a gumball machine—while cleaning the house. Maybe they were my stepson's, maybe they were the dog's. Don't ask me why, but those things were as valuable as gold to me. I just had to try them. And with me, one is never enough: I needed two. I had to have that full feeling.

One night, I took my usual shower, with my mirror and toothbrush holder—not too much—and made my way to the bed. Now for the *coup de grâce:* the balls. I rolled over on my stomach, propped myself on the pillows, and held my clit between my fingers while ever so slowly sliding the first

ball into my ass with the other. "That's not too hard," I thought. "Didn't even have to use lube." Hmm...I needed to make the second one last longer.

I started rubbing my clit as I popped in the second ball. Any contortionist would have been proud, let me tell you. I worked myself up to an orgasm as the last bit of the second ball slid all the way in. Oh, God, it was wonderful! I don't know how long I lay there in a state of bliss.

Eventually, it dawned on me that I could no longer feel the beautiful full sensation those balls provided. They must have moved up a bit. That just-over-the-ridge feeling was gone. "Uh, oh," I thought. "well, let's not panic yet." I waddled to the bathroom to see if I could wiggle them out. It shouldn't be a problem, right? I kept thinking, people shove things up there all the time (dildos, yes; Superballs without strings, maybe not).

My first attempt having failed, I resorted to artificial lubrication. I tried every kind of kitchen oil I could find, but I just couldn't get hold of those things. Worse, now they were really slick. Back in bed, I almost fell into tears. Look where my libido has gotten me this time, I thought to myself. I started trying to craft a story for the paramedics. Would it be better if I put on clean underwear?

I figured I'd better try again. Again no luck. In my hormonal insanity, I had decided that if I were to bear down too hard, I'd certainly go into labor. But maybe, if I pushed just a little...no dice.

A little harder. Still nothing. "Okay, it's do or die time." I finally decided that it would be better to be in labor a couple of weeks early without the balls than to not be in labor and feel like a Richard Gere wannabe in some remote West Virginia emergency room.

Needless to say, the last time was the charm. They came out without a hitch—and without the onset of labor. I never used those balls again, which isn't much of a

surprise, but I keep them in my bedside table to remind me how absolutely, uncontrollably insatiable I was at the time.

Tricky Dick

Shannon René

About six months ago, masturbation stopped being a private affair for me and started to become more public. I had taken a job at the Crazy Horse theater in San Francisco, performing toy shows for men and women in the club's VIP booth.

After a few weeks I took to the big stage in my first "dance" feature. Oh, there was dancing, all right, but mainly it was a week of intense toy play, four half-hour shows a day. And I was getting paid for it? I figured I had found my true calling.

During one of the last shows of the week, I had the DJ play a clip from the soundtrack to "Good Morning, Vietnam!" where Robin Williams announces, "The Big Dick is here! The Big Dick is here!" Then he started my music, and I walked out with "Kong," my humungous dildo. I love this toy! It reminds me of Willie Nelson's guitar with all the scuffs it has on it. Kong has amazing stage presence; I see so many tonsils whenever I walk out on stage with it.

The first part of the song is a tease. Completely naked, I made my way down the runway, stroking and licking Kong. Slipping beneath the rails, I hopped into a shy man's lap, looked him directly in the eye, and sang the chorus to the song: "You're not rid of me; no, you're not rid of me." I think I actually scared a couple of these men who feared I

might obsessively show up at their door the next day.

I sat down on a chair on the runway just as the tempo of the song changed to a slow pulse. Laying Kong between my breasts, I propped my feet up on the rails of the stage. With my legs spread for the world to see (you know, there's nothing more powerful than a woman with no shame), I started to masturbate by gently tugging on my hood ring while slipping a couple of fingers inside my pussy.

(About halfway through the week I had discovered a wonderful thing: I could fist myself. What a treat! "Look, ma, no hands!") I chuckled to myself as I continued to discover areas of my insides that only my ob/gyn had known before.

Then it was time for the finale. The tempo changed again, hitting a repetitive refrain of, "Don't you wish you'd never, never met her!" I picked up Kong and gingerly started to put him in. After nearly twenty shows in five days, I was pretty well loosened up, but I was feeling quite tender inside. I wondered if they'd notice if I took it easy this time? Nope, I'm a professional, I have to get through this. I let the pulse of the music and the captive attention of the audience charge me.

I started to slide Kong in and out, slowly at first, giving my body some time to adapt (and building a theatrical "ouch" factor for the audience). With each stroke I picked up the tempo, until finally I was pounding vigorously with clenched teeth. Tears came to my eyes. "Oh God, oh God," I moaned.

Yeah, more like "Oh God, I want to stop. I'm so exhausted."

But at that point of utter exhaustion and pain something wonderful happened. An inexplicable wave of heat came from the audience, went into my torso, and rushed out the top of my head. The pain suddenly stopped, leaving me to focus on what felt like tingling tendrils of light

shooting from my head up through the ceiling. I felt like I was a gateway. It was quite overwhelming and my tears welled up again.

For the remainder of the song I sent out a cry, a call of some kind, and then, spent, let the music end. A falsetto voice sang, a capella: "Lick my legs, I'm on fire. Lick my legs of desire...." I slowly pulled Kong out and collapsed from my chair into a head-down bow on the floor.

On the recording, the song is followed by massive applause, but that night I could hear the cheers of *my* audience over the pounding from the loudspeakers. I felt such a sense of completeness and accomplishment, I don't think it would've mattered if I were being booed. I had truly given everything I had to them. I could do no better. All my life people have said that all I need to do was my best. At that moment, I finally believed it.

Confessions of a Jerk-off

B.D. Mann

I grew up in a small town in the mid-west and was what I consider to be a fairly normal boy. The first unmistakably sexual feelings that I can clearly recall occurred when I was about nine years old. My brother and his friend had built a fort in the friend's backyard and they invited me back there once in a while. They had maybe half a dozen *Playboy* magazines stashed under the floorboards, and I remember looking at pictures of bare-chested women with a stiff little boner jutting from my open fly.

My brother and his friend tried to show me a couple of times how I could make myself feel real good by rubbing the underside of my erect penis with my knuckles, but at that point my circuits were so overloaded just gazing at the pictures and feeling the effect this had on my weenie, that I hadn't made any real effort to practice the technique.

It wasn't until at least a year later, one evening while I'd been soaking in a hot bath, that I first truly discovered masturbation. I'd been lying in the tub flat on my back, almost fully submerged, my nose and mouth just above the water so I could breathe. I guess it was the feel of the cold air on my genitals, when they lifted up out of the water, that caused me to get an erection.

I started to gently bounce the rigid pole of flesh quickly between my fingers and thumb. I didn't do it because I

expected it to feel good, but simply because my boner looked so silly bouncing around like that. But after doing it for a few moments, the sensations that swept through me caused me to continue.

I didn't ejaculate that first time, nor for a couple of weeks after that, although I did continue to experiment every night as I lay in bed, patting, squeezing and rubbing my stiff boner until the intensity was too much to endure, and I was forced to let go.

The first time I actually squirted off was a shocker. One night I kept rubbing myself just a little bit longer than I had on previous occasions, enduring the almost unendurable overload of sexual stimulation for just a few seconds more, and much to my astonishment I suddenly started to piss my bed, or so I thought.

To be perfectly honest, at the age of ten I'd never learned that anything other than urine was supposed to come out of your weenie. When the fluid started to squirt from the tip of my hard cock, and I felt the wetness on my fingers, I was certain that, like a three-year-old baby, I'd just wet the bed. But the relatively small amount, as well as the thick, slippery, feel of the fluid, told me that this was not piss after all.

Soon I was as good a jerk-off artist as any other healthy boy going through puberty, quite possibly better than most, since I played with myself constantly, doing it three or four times a day. Once at night, again in the morning, then once more after school, while sitting on the toilet in the bathroom, two times if it was the weekend or if I was out of school. As I said, an average teenage boy.

Then something happened that has forever left an imprint on my sexuality.

One afternoon while cutting through the field behind the house we lived in at the time, I found a big stack of pornography, including several of the very first *Hustlers*.

For a horny boy of fourteen, it was a tremendous find. This, however, was not the occurrence that had such a profound effect on me, though it surely contributed to my current affection for pornography.

It was the fact that I needed a place to hide my naughty treasure that led to the event. I couldn't bring it home, since I was certain my mother would somehow stumble across it, and this was stuff you certainly didn't want your mother finding. A couple hundred acres of woods separated our subdivision from another. I'd spent quite a lot of time exploring these woods and had discovered a private little hidey hole.

It was a grass clearing, set among a few fallen trees and a thick growth of sticker bushes. Five-foot-tall grasses and weeds grew around it on all sides, and unless you knew exactly where there was a break in the bushes that you could crawl under, you'd never know it was there. I could crawl inside, lie back and feel secure that, should anyone happen to pass by, I would remain undetected.

That became my jerk-off spot, the place where I'd sit perusing my magazines and playing with myself for hours at a time. It was exhilarating to lie out in broad daylight, the blue sky visible above me, my pants and underwear pulled down to my knees, so that my cock was exposed to the breeze and the sun beating down.

One sunny autumn afternoon after school, as was my routine, I headed straight for the woods. Before long I was in a prone position, stiff cock in one hand, a magazine held above my face in the other, a grimace of masturbatory euphoria on my face.

Suddenly I heard the sharp snap of a stick nearby, followed by an excited whisper, a giggle, and a shushing sound. My heart nearly exploded in my chest as I realized the implications. I instantly reached for my pants and jerked them up, my hands fumbling to force my still rigid

boner into the confinement of my underwear and jeans.

As I did this, I caught sight of movement just to my left, and turned to look at a large bare spot in the foliage. Certain plants had thinned out since the summer and I saw two figures moving just a few yards away.

"God! He sees us!" a decidedly female voice exclaimed.

Another girl laughed. "So what?" she said. "We see him too! Hey you! We see what you're doing in there!"

I fought to simultaneously pull up my zipper and crawl across the grass to the little depression where I hid my porn, somehow still thinking that I was going to be able to conceal this awful transgression.

"How do we get in there?" said the second voice, which I could now see belonged to a blonde trying to peer past the brambles. I hoped that it would take them awhile to find the entrance to my little jerk-off nest, but I'd grown careless. The formerly invisible entrance now had a visible path leading right to it, since I had used the route so often. It was mere seconds before I looked over my shoulder and saw the blonde girl crawling head first into the clearing with me. She was quickly followed by her redheaded companion.

The blonde confronted me with a wide grin. She looked like she was maybe sixteen, with long thick hair feathered back from her face. Much to my horror, I recognized the redhead from school. Her name was Nancy. She was a year older than me and we had a couple of classes together, during which I'd spent lots of time staring at her tits. As her wide, green eyes focused on me, I could tell she recognized me as well.

"So, kid, you just sitting out here looking at dirty pictures and beating your meat?" the blonde asked with a smirk, ignoring my attempts to block her way as she reached behind me to grab one of my porno mags.

"No! No, I...!" I lamely tried to lie. My face burning with intense embarrassment and shame, I felt myself trying to

shrink back into the farthest corner of my little hideaway.

The blonde ignored my denials, and laughed, pointing to my still bulging crotch. "He's still got a boner!" she cried. "Looking at all the naked ladies has him stiff as a board!"

I watched Nancy staring at my crotch and dropped my hands in a belated attempt to conceal my condition. She too was flushed red from embarrassment. But the way she stayed focused on my crotch, even after I'd dropped my hands down to conceal it, made me think that she was aroused as well.

"I know him," she said in a low tone. "He's in my social studies class."

The blonde's face lit up at the news. "You know this little pervert?"

Nancy nodded and I wished that I'd suddenly fall over dead.

"Oh my, my," the blonde said with mock concern. "What will everyone say when we tell them that we found him out here playing with his dick? Won't they be shocked?"

I felt panic rise inside me and my eyes grew suddenly hot as tears threatened to swamp them. "Hey! Hey, you can't do that!" I tried to come off as forceful, but knew, even as I spoke, just how pathetic I sounded.

"Wanna bet?" she sneered, and wiggled her hips. "Nancy will make sure that, by this time tomorrow, everyone at Washington Junior High knows what a jerk-off you are. You can count on it!"

"No! No, you can't!" I pleaded, feeling like a cornered animal.

The blonde was smirking again, clearly enjoying my panic. I sensed that Nancy too was somehow enthralled by my predicament, but imagined a sympathetic glimmer in her eyes.

"Well," she said. "I guess we don't have to tell anyone."

"What?" the blonde exclaimed. "Sure we do! I mean,

why wouldn't we?"

"I don't know, maybe he could do something for us to keep us quiet."

"Like what?" the blonde persisted.

"Maybe he could...." Nancy's face suddenly grew even redder, and she looked self-consciously at the ground. "... I thought that maybe he could...." Her voice trailed off, but in the next instant comprehension came across the her friend's face.

"Yeah! That's it!" the blonde grinned. They fixed me with hungry stares and I shook my head, though at that point I hadn't the slightest idea of what they were going to propose.

"We won't tell anyone," she assured me. "As long as you give us another jerk-off show."

I gasped, shook my head even more vigorously, and stammered incoherently.

"Look here, you stupid dork," the blonde sneered. "Either you're going to start doing exactly what we tell you, or we're going to turn around and crawl out of here and go tell everyone we know about your nasty little habits."

I continued to shake my head, the very idea of willingly exposing myself to them causing me to edge instinctively towards the exit hole. The blonde moved to block my way.

"In fact," a wicked twinkle flashed in her eyes, "I think that instead of telling them that you were looking at pictures of naked girls, we'll say that you were looking at pictures of naked guys."

I gasped and looked at her in utter horror, shaking my head, but I could tell from her smug smile that she meant every word.

"Go on, " she said, sitting cross-legged on the ground near the exit. "Take your pants off. Do it, before we leave."A moment later Nancy took a seat next to the blonde and they both looked expectantly towards me. This was one of the

worst moments of my life. I knew I was going to have to do what they said. A hormone-ravaged fourteen-year-old boy, filled with self-doubt and anxiety, forced to expose himself to two older girls; I very nearly died from the overwhelming shame.

But at the same time I was experiencing the sexual turn-on of my lifetime. When I undid my pants and pulled them and my jockey shorts down to my knees, I exposed the most intense erection I'd ever had. I could literally feel their eyes focused on the rigid organ as it throbbed lewdly out from my crotch; this only served to make it all the harder.

They made me model my erection for them, showing what the swollen pole looked like from the side, when pushed up towards my stomach, or down between my legs so that the head was pointing towards the ground. They giggled when I let go of it and the knobby head came bouncing stiffly back up to full attention. They watched in rapt fascination as I lifted my scrotum and rolled each testicle between my thumb and forefinger so that they could see them individually.

I squeezed myself for them, stroked my engorged length, and rubbed my glans until I felt my balls pulling up in anticipation. However, because I was much too embarrassed to ejaculate in front of them, I let go and left myself throbbing and unsatisfied. But the blonde wasn't having any of it.

"Don't stop yet!" she scolded, a breathless quality to her voice. I looked up and noticed for the first time that both girls were squeezing and rubbing their own breasts through the fabric of their shirts as they watched me.

"Keep going." The blonde commented to Nancy: "If he plays with it for long enough it will squirt off for us."

"Isn't that right?" she spoke to me again.

I reluctantly nodded.

"See! I knew it! I felt it when Gary squirted inside his

underwear once, after I'd rubbed him for a while through his pants, but I've never actually seen it before."

I wrapped my fingers around my swollen cock and began stroking again. I was still terribly embarrassed to be exposing myself to them, yet at the same time, I was exhilarated to have noticed that both of the girls were clearly getting turned on by watching me do it.

I grunted low in my throat, as most of the muscles in my body tensed. My hand was a blur, jerking rhythmically, and I let out a strangled cry as I finally succeeded. A thick rope of milky cream came jetting out from the tip of my cock and seemed to hang in mid-air for a second before it splattered onto the trampled grass before me. Both girls gasped and stared as a second, then third, squirt sent additional come spraying in all directions.

For a brief instant, as they gazed at me with open awe, I didn't feel ashamed, but rather proud that I'd performed so skillfully.

However, after the last dribbles of juice had been coaxed from my dick and my erection started to falter, the sense of triumph was quickly replaced with intense embarrassment. The feeling was apparently mutual. The girls abruptly stopped fondling their breasts through their clothing and exchanged a guilty look. Even the blonde, who'd been so crude earlier, was now quiet and self-conscious.

"Come on, " she said to Nancy and turned to crawl towards the hole in the bushes. "Let's get out of here."

I quickly pulled up my pants and stuffed my sticky penis back into my underwear. By the time I had zipped up, the girls were out, and I could hear them disappearing into the woods.

I faked being sick for over a week to avoid going back to school, afraid that Nancy and her friend had gone ahead and told everyone everything anyway. When I finally went back, I was relieved to find that they hadn't. I found myself

avoiding Nancy, which wasn't that difficult, since she avoiding me as well.

For almost six months I lived in fear that she was going to confront me, and then one day she was gone. I later found out that she'd moved away, but instead of feeling relief, I felt disappointed, as if I'd missed a remarkable opportunity. It soon became clear that I had actually been hoping she would confront me, hoping she would insist that I do it again.

The thought of "performing a jerk-off show," as the blonde had so eloquently put it, has remained my primary sexual fantasy into adulthood. Many times I have stood for hours before a full-length mirror masturbating, imagining that I am being forced to do so for a room full of admiring women.

From the moment I first heard Nancy and her friend, to the time they left me standing there by myself in my hideaway, couldn't have been more than fifteen or twenty minutes. Yet that brief encounter has had a greater effect on my sexual development over the past nineteen years than anything else I'm aware of.

Soliloquy

Alexandra Gray

L ying on my bed, I massage my neck, gentle fingers loosening the tight muscles. The released energy flows down into my pelvis like golden water, filling all the crevices. The outer world recedes and the sea inside me rises, its rhythm my own heartbeat.

I touch between my legs. My vagina is leaking juices, and I cover my fingers with this proof of my body's desire for pleasure. Bringing my fingers to my face, I fall in love again with my sea smell, so familiar and reassuring. My hands trace the curves of my body, soft skin on soft skin. My body begins to expand, soaking up the energy, stretching with delight.

Touching my breasts with the tips of my fingers, I stroke the skin around my nipples. My nails rub the nipple tops lightly and the muscles between my legs contract, circuits in my body connecting again in pleasure. I press my nipples between my fingers several times, excitement spreading through me as the pelvic muscles give their immediate response. My breath quickens and my body feels more spacious, more surely my home.

My hands move over my belly, over the mound, fingers weaving in and out of the fine, curly hair. I stroke the insides of my thighs, pressing the sensitive skin around my clitoris and the entrance to my vagina, careful not to come

too close. Those places ache to be touched, but I hold back, wanting everything to flow together. Don't rush, don't rush. I hate ending up not completed, muscles and tissues still engorged with sour energy.

Vibrators surround me and my body tingles with memories of past pleasures. Soon one is whispering promises to me, echoing my sounds of pleasure as it slides into my vagina. I thrust it very deep in me, pushing against my cervix again and again. My vagina is turning itself inside out, every millimeter reaching for the feeling. Desire pours through me, washing away my thoughts.

I bring the vibrator gently down on my clitoris and my body embraces it, wanting the source closer, harder. Pressing down, gathering in my energy, I hold my breath. Beyond me, outside of myself, my muscles spasm and contract and let go. I am caught in a tide, no sailor now, but a piece of flotsam being rushed to shore. When the last wave has carried me in, I am left emptied, at peace, the center of the universe. I have found myself again. I am whole.

Sex 'n Sox

William Smithson

I decided early on that asking questions of my parents
was mostly pointless. Talking with friends was better.
But keeping questions and comments about most
things to myself was the safest. Especially sex. Sex
was but a vague mystery to me.

That all changed one Sunday afternoon. While soaping
and washing my genitals in the bath, I saw my suddenly
enlarged penis standing tall and demanding that I stroke
it. This was terrible, wonderful and amazing! Awkwardly
using both hands, I was nearing my first explosive ejacula-
tion when I heard, "Hi, Billy. What are you doing?"

A mixture of fright, guilt and embarrassment bolted
through my stomach and chest. My mother had sent my
five-year-old neighbor Dickie up to talk to me. Before I could
say anything, he pointed at my penis and said, "You have
a big one, Billy."

Later that night in my bed under the security of dark-
ness and behind locked door, I successfully completed what
had been so rudely interrupted earlier. From that time
forward, life took on a whole new meaning. My amazing
discovery propelled me into years of self indulgence, dras-
tically changing my attitudes toward myself, girls and my
parents.

Naturally, my grand and glorious new source of

pleasure and happiness had to be kept secret. The secrecy added excitement to my new obsession. I experimented to find new ways, times and places to increase its frequency and intensity. Practice, indeed, made perfect. And, "Try, try again" became my motto.

Usually, the great event took place as at night in my bed, two doors down the hall from where my parents slept. Silence was essential and easily mastered, but getting rid of the stuff was an ongoing, never fully solved challenge. Most commonly I ejaculated into the inside of a sock I had worn that day. One night, I would masturbate into my left sock, the next night into the right sock. It wouldn't be too bad wearing the socks the next morning, providing I had used only one of them. Although the sock—or socks—were usually stiff the following morning, it was tolerable. It was by far superior to the alternative of having my mother find "come" on the sheets and blankets.

Breakfast time was often difficult. I usually felt self-conscious and guilty, especially if I had masturbated two or three times the previous night. Then, for sure, both socks were stiff. The greatest challenge was to sit nonchalantly at the table while simultaneously wiggling my toes inside my shoes to soften my socks. When Mom asked how I had slept, I usually answered with a forced smile and something like,"Uh... uh... fine. Why?"

Neither my mother nor my father ever directly asked or said anything about this part of my youth. I attributed this to the fact that I frequently prayed, asking God for His protection from my parents' intrusion into my secret life. I could not bear the thought that some day or night my parents might find me in the act with cock in one hand and sock in other.

My fears about discovery were reinforced when one of my best friends—Freddy—was nearly caught red-handed and white-faced by his mother. It was mid-morning on a

Saturday. In his second floor room, he had just ejaculated into a handkerchief and had thrown it down the laundry chute.

By chance, his mother was in the basement sorting out a dirty clothes basket at the bottom of the chute. As she reached into the basket, Freddy's wet hanky dropped onto the back of her hand. Freddy heard her screams three floors up. She ran up the two flights of stairs, burst into his room to find a shrinking Freddy and shrieked at him, "You're filthy! You're sick! Only crazy men do this terrible thing! You belong in an insane asylum!" She warned him that his father would deal with him when he returned home from his business trip.

Freddy waited for days for his giant father, Sven, to return home to deal out a terrible punishment. Until then, Freddie masturbated as often as possible, anticipating that his member might soon be dismembered. When Sven finally returned, he didn't say much, but the next weekend he drove Freddy to the nearby state prison. Once there, Sven told his son that many of the men inside the prison were there because their brains had gone soft from doing what Freddy was doing to himself.

But Freddy was only one of many friends passionately involved with himself. There were Jeremy, Jim, Walt, Murk, Jocko, Suds, and more. Jeremy's story was especially unusual, I have always thought. He was a childhood friend whose parents were devout Christians, fundamentalists of some kind. My mother often said that Jeremy was my finest friend because his family were such upstanding, God-fearing people.

When I was thirteen, I met Jeremy again. We were both shy and mostly quiet during our first meeting until he suddenly blurted out, "Billy, do you jack off?" I was dumbstruck. Jeremy? The good Christian boy? My mother's model for me?

I mumbled awkwardly, "Uh, maybe once or twice. I forget." Jeremy's eyes lit up, he became animated and said excitedly, "Well, a walk-off is even better!"

"What's that?" I asked still disbelieving this was Jeremy.

"Well," he answered with a happy face, "You lie naked in the bathtub and get your dick hard, then stick it just above the water. Next you take a fly and pull its wings off. You put the fly on the head of your prick, and let it 'walk you off'!"

I can still hear him as he ended his instructions in a high-pitched giggle.

Ingenious, I thought. I had never known Jeremy was this creative and impure. I couldn't wait to try it, but somehow I never did. I think I felt too sorry for the fly.

Later that same day, Jeremy and I decided to play basketball in my parents' church basement. He suggested, "Let's play with our dicks hanging out." So we did, and when we got erect we jerked off together, spilling our come onto the church basement floor. The large room was used daily for prayer meetings, potlucks, and other important meetings by the congregation, especially the Ladies Aid Society. I imagined with horror that I could see the adults who would gather there, on their hands and knees inspecting the floor for stains and dribble spots on the hardwood. They somehow would know, I worried, just whose semen this was. For a couple of nights I lay awake waiting for the authorities to knock at the front door and haul me away.

Of course, there were dozens of other ways to be caught by the adult world. When doctors examined you, they could tell if and how much you had been masturbating by carefully examining and measuring your penis to see if there were recent growth marks or new amounts of foreskin. A saggy foreskin was a dead giveaway, and I knew I was as good as dead the next time I visited a doctor. My foreskin

sagged a good one-sixteenth of an inch and I figured that Dr. Domer could somehow calculate the amount of sag added over the past week.

Miraculously, when I did visit Dr. Domer, his eyesight apparently had gone bad because his examination of me revealed little to him. However, I feared that his last test, shining a large black flashlight into my eye, would reveal my secret. He would see that my pupils had grown immensely over the previous year. My friend Suds had told me that the same thing happened to him at his doctor's. I believed my secret would soon be out. I squeezed my eyes shut and could hear him saying to my mother:

"Mrs. Smithson, what your son has here is a case of over-dilated pupils. What this means is that Billy has been playing with himself daily, sometimes twice or more. He's not only insane from it, but he's also losing his eyesight. I recommend you have him locked up as soon as possible for your family's sake. You don't want him disgracing you any more than he already has. And hopefully after a few years in the asylum, he'll regain both his sanity and his eyesight."

I could hear my mother screaming and see her falling to her knees in prayer asking for God's punishment upon me, and for His forgiveness of her for having failed to raise a carbon copy of Jesus. Or she might faint dead away on the floor.

As it turned out, I heard the good doctor say to my mother, "You have a fine, healthy son here, Mrs. Smithson. You can stop worrying now about those pulsations in his ears. It's something I'm sure he'll outgrow. Just feed him vitamins, and give my best to your husband. You've got a wonderful little family there."

That pulsating sound in my ears was a real irritation. As my mother and I walked out of the office, I concluded that the noise had to be the result of my phallus's nightly throbbing. The combination of my body's quivering before ejaculation followed by the violent thrusting of my pelvis

and upper legs during release probably caused those pulsations. My naive and anxious mind warned I might even go deaf in a year or so.

But I soon forgot those concerns when two new problems preoccupied me. From all that friction, I developed scabs below the head of my penis. Unfortunately, one of my so-called best buddies spread the word around, and for a year or two, I was known as Scabs. When my curious parents asked me where I got my strange new name, I responded as casually as possible with my usual smile, "Oh, that! Uhhhhh, that's because I always scab the ball from somebody in basketball practice. You know, steal it. The coach thinks I'm good at that." I recall my parents' doubting glances and shoulder shrugs as they slowly rose from our overstuffed sofa and left the room.

My second new worry had to do with my future. At the rate I was going, I figured my sperm supply would be used up before I was twenty-one. Consequently I tried rationing my output. For a start, I stopped masturbating on Sundays. That lasted one week. Next, I splashed cold water on my penis before going to bed. Then I tried hitting it on the head with a sharp snap of my middle finger. I had heard that nurses did that to male patients in hospitals when the men got erections. I tried reading in bed and doing arithmetic in my head after I turned out the light. But nothing worked, I couldn't keep my hands away from my nightly erections. I wanted to ask friends how they kept from doing it, but I was too embarrassed. When I was successful in skipping a night, the following day's or night's masturbation was even more exciting. I soon gave up trying to stop. I was hooked for life.

Masturbation 101

by Ariel Hart

When I was barely eighteen, I saw a movie which will be etched into my sexual psyche forever— *The Sailor Who Fell From Grace With The Sea.* In it, Sarah Miles played a lonely young widow. One night, while sitting at her dressing table, she worked her fingers between her legs and closed her thighs around them. She had the most exquisite expression on her face. The scene was very brief, beautiful and stylized and when I saw it again years later, I couldn't believe it had made such a great impression on me. But it did.

Bells rang. Fireworks flared. The "Hallelujah Chorus" rattled inside my head. I felt euphoric. I felt like an idiot. Why hadn't I thought of touching myself before? I couldn't wait to try it out. When *The Sailor...* was over, I practically ran home, albeit on shaky legs. Safely locked away in my room, I remembered what I had seen in the movie and gave it a shot. To my amazement, it worked. After that, I did it constantly and actually became quite good at it.

Eventually, I learned the name for the thing I was doing. It was called "masturbation" and it was bad. Such a long, ugly, unpleasant-sounding word. It seemed like a more appropriate name for a tropical disease or a mysterious bodily function which involved heavy secretions of bile. I still masturbated, but now something new became

part of my repertoire. Guilt. While I diddled, I felt dirty, perverse, evil. Following each climax, I swore I would never do it again. Until the next time. Drifting into orgasmic nirvana was the most gorgeous sensation in the universe but the sticky-fingered aftermath made me feel like a criminal. I would be ostracized if people found out. Shunned. And no one would ever shake my hand. No, I would never do it again. Never. Until...until the next time.

Years passed. I grew into a sexually suave woman who wrote erotica. But my attitude about masturbation hadn't changed. In my travels, I came across a flyer about someone named Betty Dodson who conducted what she dubbed "Bodysex Groups." In them, women talked about their bodies as well as how they felt about jerking off. Call it "hands on experience." Call it "Masturbation 101." I was both shocked and intrigued. I mentioned Dodson's Bodysex Group to one of my editors and to my amazement, he suggested I attend. In fact, the magazine even paid my way.

DAY ONE

So, there I was, sitting on the carpet in the middle of Betty Dodson's living room with eight other women, stark naked with nothing to hide behind but my nervous wit, no designer labels or social conventions to protect me. We were an intricate web of spider veins, gently mottled cellulite and graceful Cesarean scars. And the funny thing was that even though we were all imperfect, we were all strangely attractive.

Taking turns, we introduced ourselves to each other. We explained why we were there: to learn how to love ourselves, to have better orgasms, etc. We were admitting things to each other we hadn't dared tell our closest friends. Dodson presided over all, a spry, impish woman in her sixties. With her close-cropped gray/blond hair, strong, well-muscled body, sparkling eyes and unassuming Mid-

western friendliness, she immediately put us at ease.

Next, there were psychological exercises to get us in touch with the male (aggressive) and female (submissive) aspects of our personalities. A low table covered with spring water, fresh fruit and delicious banana bread sat invitingly in the center of the room. Very soon, this began to feel like a party instead of a penance. After a while, we even forgot that we were naked.

We laughed as we discussed childhood misconceptions about our bodies and sex, plus society's shame concerning its "dirty little secret" (gasp!)—masturbation. We almost cried when Gina told how an ex-lover used to refer to her florid genitalia as "liver lips" and we assured her that her cunt was indeed comely. The day sped along. Soon, Dodson announced that it was time for "Show and Tell."

One by one, we spread our pussies apart with our fingers. Aided by a little hand mirror, we looked at ourselves and described what we saw. The idea of this exercise was to show us that there wasn't one "right" way for a woman's body to look. There were many different ways and they were all fine. There were pussies with uneven lips, some with bumpy goose flesh and some with folds at the bottom "to catch the drips," Dodson grinned. There were heart-shaped ones, pink flowers, fleshy seashells, a two-toned cunt and the pudgy "peach that ate the butterfly" (mine).

At the end of the first day, we applauded our unique and lovely snatches as well as our bravery. Then we went home.

DAY TWO

When I arrived the next day, Dodson was setting up the vibrators. But not just any vibrator. Hitachi's "Magic Wand," the Mercedes-Benz of electric lustmates. Two by two, they dangled enticingly from long extension cords. We

were ready to roll. And roll we did.

But first, we breathed, unclogging our nasal passages with our pinkies. Breathing correctly was essential to any bodily function, but most of us didn't know how to do it right. Dodson stressed that what we would do next was merely an exercise, not the real thing. Under no circumstances were we permitted to come. Not yet.

A few of us—myself included—had never used vibrators before. Besides, being a vegetarian, I preferred the natural method. (As Dodson had urged the day before, I had brought my own DOC—Dildo of Choice—a zucchini which I'd lovingly pared and fashioned into my dream-dick, complete with pee-hole.) Others had vibrators and hated them. Pat used a palm-attached job which was famous for snagging pubes. Jeannie had a similar model her husband loved to use on her, but it made her feel as though she were being simonized.

The Magic Wand was a completely different piece of work. If it had had a steady job, I might have married it. At Dodson's urging, we skimmed the vibrators across our inner thighs and tickled our pussies. We pleasured parts of our bodies that weren't used to being pleasured: our hearts, the tips of our noses, our scalps. Slowly, we found our way back to our cunts. Dodson's voice sang out in constant reminder to keep the touch light, to keep our pelvises moving and to keep breathing, always to keep breathing.

I had been afraid that I wouldn't be able to come at all, but after only a few seconds, I felt an orgasm trembling on the fringes. Could I hold back? Did I want to? Could I sneak one in without Dodson knowing? Fat chance. She was a pro, and anyway, I couldn't come without screaming. Luckily, Dodson's next command was to douse the vibrators.

Switching the wands to our left hands, we practiced massaging our swollen buttons from underneath. Varying the angle and the touch made the sensation completely

different. But in any position, it was difficult not to grind, not to just smash the machine's humming head into my clit for one violent, chunky, delightful orgasm.

Just as I started to glide toward the pinnacle, Dodson's all-too-cheerful voice told us to snap the vibrators off again. Our next position was down on our knees, straddling a throw pillow upon which we rested our vibrators. I was aching to resume, but Dodson was more concerned with Jeannie, who had to squat way down to make contact. Dodson suggested propping another pillow between her legs so she would reach the wonder wand comfortably.

"It's all right," Jeannie assured her.

My clit was afire. We were sex jockeys poised for a long, hard gallop. But still Dodson persisted, "Are you sure?" she asked Jeannie.

"Damn it, Betty Ann, she's fine!" I snapped. "Let's go!"

When everyone stopped laughing, our fearless leader finally gave the word. We humped our vibrators in an easy rhythm, eight damp women riding bareback. I looked down to see my dark cunt lips splayed against the Wand's mercilessly whirring head. It was slick from the almond oil and my own juices. Just as I was contemplating another explosion, Dodson ordered us to stop. This time, all of us sighed audibly as Dodson explained her tactic: "If you masturbate for 20 minutes, you get 20 minutes worth of orgasm. I'm teaching you gourmet self-love, not fast-food come sessions."

Leaning back onto our haunches, we grasped the vibrators by their wires. As they wandered freely along our pelvises, the sensation was almost imperceptible, yet impossible to ignore. I gave into it, then backed away from the delicious tease. Just as something volcanic was starting to build, Dodson chirped, "Vibrators off!"

Sitting Indian style, we held our buzzing lovers with the soles of our feet. In this posture, we arched toward the

vibrator, then curled our spines away. I was a hedonistic princess plucked from an erotic cave drawing which didn't yet exist. I was an Amazon goddess. I was...I was...I was ready to kill Dodson for making us turn off the vibrators and change positions again.

On our backs this time, we held our trusty dildos at the entrances of our cunts. The idea was not to push them inside—our pussies would soon draw them in of their own volition. Magic Wands stimulating our pubic mounds, we pressed our dildos against our slits. My pussy slowly sucked in the cool, skinny zucchini. I pumped gently, ice turning into heat, electric blue, soothing and sweetly tormenting. I felt I could do this forever—or until Dodson declared another erotic intermission. You can probably guess which came first. It wasn't me.

At this point, we were nearly ready to lynch dear Ms. Dodson. Aware of this distinct possibility, she was wise enough to decree practice time over. No more cunt calisthenics. This was the real thing. We were awarded some time to sample what we'd just learned and told to come as copiously as we wished. Within a few minutes every woman in the room had had at least one orgasm.

Just when I thought I couldn't endure any more pleasure, Dodson said to keep on going. My pussy was still spasming from my first orgasm. My clit felt like a miniature engorged cockhead and I couldn't bear to touch it directly. Palming my mound, I pressed the Magic Wand against it, jiggling the hand that cupped the crotch. The stimulation was light, but oh so relentless.

It was late afternoon and the winter sun was setting. In the soft, dim light, the scene resembled an impressionistic masterpiece. Degas's ballerinas stripped bare. Lautrec's whores on their day off. Sighs and voices enveloped me like a soothing drug. A heap of pillows cradled my head. I dreamily watched the women around me massaging their

cunts, the room teeming with a contagious sexuality. Whenever I thought I was fully satisfied, my hand absentmindedly found my clit. I watched as Pat lay on her back, thighs hugging her vibrator. Jeannie was on my left, propped up on one side. She had slipped the Wand between her legs and softly pressed against it.

My mind raced to the positions we'd tried. I wanted to come in each of them at least once, starting with the most difficult. With both hands, I gripped the tireless Wand against my pelvis, rocking my hips in and out of the feeling. Damn it, I was an Amazon goddess, spasming and throbbing in powerful orgasms. Any man would think me irresistible: Just look at my milk-chocolate cunt lips, my glistening pubes, my nipples hard as pebbles. I was beautiful!

How many times did I come that afternoon? Somewhere between eight and infinity. At one point, the orgasms seemed to tangle together. Sometimes I just watched, then was silently moved by the room's passionate aura to masturbate again. Eventually, as easily and mysteriously as it had evolved, the sexual magic seemed to dwindle, the mechanical hums reduced to only one or two.

With glowing faces and bodies moist with sweat, we discussed our orgasms. There were smiles and a deep sense of satisfaction. Approaching a climax was no longer like climbing a mountain on our backs: a monumental, difficult task. Now it was easy—each and every one of us could. The question was no longer if but how many.

The mood was quiet and pensive. Dodson likes to end her Bodysex Groups with a communal massage. It was a gentle way to usher us from orgasmic plateaus back to the harsh reality of Manhattan bustling outside the door of her cozy high-rise apartment. The sun had set by now. The room was dark except for candlelight. One by one, each of us was massaged by the others. Before the workshop offi-

cially disbanded, we formed our last circle and lightly joined hands. Energy surged through our fingertips. Then we dressed and were gone, each to her own life, never to see each other again.

The next day, my body ached pleasantly, as though I'd exercised too intensely. Perhaps I had. I hurt, but was elated at the same time. There was a wonderful secret alive inside of me, yet I told no one. I no longer felt embarrassed about the way my body looked. I no longer had qualms about touching it and giving myself orgasms. You see, I had taken "Masturbation 101." And passed with flying colors.

Seventeen Reasons Not To

Elizabeth Irvin

I stir as the room lightens, and start to think of all the reasons not to masturbate. I struggle to hold onto the desire to do it, just as many mornings I've grabbed in vain at the remains of a vivid dream, knowing that if I don't scribble down that fragment, the whole remarkable event will be forever lost.

Why not just do it, before that fleeting urge is gone? Instead, I start making one of those lists for which I'm famous:

- Because it might make my slight headache worse.
- Because then I might not be able to get back to sleep.
- Because I might doze off again and oversleep.
- Because if I do it instead of writing now, I may never write this at all.
- Because it takes so long.
- Because it will be over so soon.
- Because my vibrator is not within easy reach.
- Because this time I may hang forever in that delicious excruciating place just before....
- Because there are no surprises in it.
- Because I can't decide whether it would feel better before or after I pee.
- Because this morning I can't picture getting off with

the limitation of having only two hands.

- Because I do this better with an audience of one.
- Because no one is here instructing me with impeccable timing, to hold back, words guaranteed to drive me right over the edge.
- Because I know there is only one orgasm in it for me this morning, and perhaps it will be an insignificant one, not really worth the wait.
- Because it will probably make me horny.
- Because it will possibly make me feel lonely.

Still...the most sensible thing to do right now seems to be to put down this pen and pinch my nipples....

An Apt Student

Maggie Michaels

I worshipped Julie. My cousin was all I wanted to be. At thirteen, she knew far more than my immature eleven-year-old mind could possibly comprehend. She was an expert on the latest fashions. Want to know about the proper shade of lipstick for a brunette? Ask Julie. How about boys and dating? There were no mysteries to her. She kept me informed on everything of importance. She even knew about the war we were fighting in Asia.

I respected her opinions, knowing that no one knew more about life than Julie. And she knew more about sex than I ever hoped to know.

I adored her.

"You ever think about what men and woman do in bed?" she asked one Saturday, staring out my bedroom window. In the next yard, Mr. Travis mowed his lawn, the muscles in his bare back rippling in the summer heat, his tanned skin the color of cognac. Julie watched him, her cornflower blue eyes studying him carefully.

"Mom says I'm not supposed to talk about those things," I replied indignantly. Not because I thought Julie's question was inappropriate, but because my mother's constant refusal to discuss anything to do with sex had rubbed off on me. Three things were never discussed in my home: religion, politics and sex. "She says I have plenty of time to

learn about those things."

Julie pulled her eyes away from the window and smiled at me. "Your mother's old-fashioned," she announced. Sighing, she tugged off her tight shorts, stripped off her cotton top, and plopped down on my bed clothed only in her skimpy bra and panties. "Maggie, do you ever love yourself?"

I sat down at the front of the bed, my eyes wide, not at all embarrassed by her lack of clothing. After all, Julie was a teenager, and she knew what she was doing. "Like how?" I asked.

A wicked smile pulled at the corners of her full lips. "I mean, stupid, do you ever touch yourself and make yourself feel good?" The summer light filtering through the window, bathed her body, turning her hair and skin a shimmering gold. Her eyes closed and she heaved another impatient sigh.

I hated it when she sighed that way. "Oh no," I replied, watching her pert nipples strain at the thin material of her bra. "Mother says you'll be struck down if you touch...."

"Stop it!" she cried, covering her ears. "I'm so glad my mother isn't like yours." Patting the bed spread beside her, she beckoned me. "Mr. Travis has made me hot, and I can't stand it. C'mon, I'll show you how to make yourself feel good."

I'd been around Julie long enough to know that she wasn't going to let me bow out of this gracefully. I'd watched her for hours, naked in front of the mirror, running her hands up and down her body, smiling at what she saw. Now she seemed determined to show me.

"Okay," I said, not daring to turn down her offer. After all, she knew about sex. Poor little Maggie was in the dark.

"Take off your clothes," Julie ordered. Within seconds I was down to bare skin. She slipped off her bra and wriggled out of her panties. Lying naked on the bed, her eyes took on a far-away look, a look I wanted to duplicate.

"You've got to think of someone who makes you hot," she whispered.

"Hot?" I sort of knew what she was talking about, but wasn't quite sure. What little I knew about sex, I'd picked up at school. Not sex ed, mind you. Just preteen girls hanging out in the bathroom whispering and giggling about boys. Certainly not a reliable source.

"You're so silly," she scolded. "Now follow me."

I watched her long-fingered hand slowly inch down her stomach. She stopped right above the golden triangle between her thighs....My eyes grew wide in fascination. Julie made her movements look so what...sexy? No...hot! Now I knew what she meant.

"You have a tiny bud," she said, her fingers dipping between her youthful thighs. "Have you found it?"

I followed her example, my fingers grazing the tip of my clitoris. "Yeah, I think so."

"Good," she sighed. "Now rub it gently, Maggie. Not too hard, now. Be gentle. It's very sensitive."

My eyes were glued on Julie. Her flawless face was beaming, her eyes closed, her fingers working their magic. "You'll feel a tingle, Maggie. Keep rubbing until you can't hold back anymore. You'll know when that happens."

"I'm trying," I said. Such a feeble attempt. My fingers weren't performing the magic that Julie's were. Out of the corner of my eye I watched her face flush, her body quiver. She bucked and cried out.

I waited...and waited. Nothing happened.

After her breathing had returned to normal, Julie turned to me, "Isn't it wonderful?"

"I—I don't know." I felt like a small child, unable to understand this mystery of womankind. "Guess I wasn't doing it right."

Julie rolled her big eyes. "Maggie, you're impossible. Lie down and I'll show you." I stretched out, holding my breath,

afraid and excited at the same time.

Her fingers danced across my chest, the little mounds of my growing breasts aching for her touch. Soft lips kissed my nipples, and I nearly flew off the bed. Julie ran her hand down my body, stopping above the peach fuzz that had recently sprouted between my thighs.

An expert finger dipped inside me. "This is what you do," she said, rubbing my clitoris gently. My world changed that second. My body was no longer something I walked around in. It was like a flower, ready to burst into bloom.

"Oh," was all I could say as her finger teased me. A warm moistness appeared, coating her finger.

"Now you try," she said, taking my finger and placing it where hers had been. "Gently, Maggie, gently."

I rubbed softly. My body grew warm. I moved against my finger, amazed at how my body responded to my touch.

"Think of Mr. Travis with his muscled, sweaty body." she whispered in my ear. "Wouldn't you love to run your hands down his back, feel those rippling muscles under your fingers? Are you getting hot, Mag?"

My finger worked back and forth. My body was growing much warmer. I didn't think of Mr. Travis, not at all. My mind was filled with the image of Julie writhing on the bed, her body flushed, her moans of pleasure like nothing I'd heard before.

"Oh, Julie," I whispered as my orgasm ripped through my body. My toes curled and I thought I'd never experience anything as earth-shaking again. The sweetness surged in me, and I stopped rubbing for fear my little bud would burst.

I quaked, a wonderful feeling of release escaping through my thighs. I held the bedspread, my body still quivering when Julie touched me.

"Wonderful isn't it, Mag?"

I stared into her eyes, wishing she'd always look at me

like this. "Wonderful," I replied, my breath finally return-ing.

She bent down and kissed my cheek. "Did thinking about Mr. Travis help?" she asked, winking at me.

Now That I'm a Male

Mark Wilson

I was able to masturbate within three weeks of the remarkably non-invasive surgery that changed my original female external genitalia to those of a male. The procedure, called metaoidioplasty, was performed to render this one remaining portion of my formerly female anatomy in alignment with my male psyche and the rest of my appearance. Some transsexual people say that genital reconstruction makes them "complete." I knew I was completely male before the surgery, but after the surgery others could know it, too. Of course, I had to learn how to use the new equipment myself before I could engage in partner sex.

When I had masturbated before, I simply brushed my hand very quickly back and forth across my clitoris. My sexual response was fairly rapid, and I could have many small orgasms in succession. Since I had started testosterone to facilitate the external sex changes two years before my surgery, my sexual response had already changed. As my clitoris grew to the size of a small penis, held down by the clitoral hood, I craved more and more stimulation, masturbating daily, whereas before I had done it only about once a month. Now I could not reach a climax as quickly, but I could experience a single, usually more intense orgasm.

The surgery freed up the neo-penis, restructuring the foreskin so it encircled the organ and didn't bind my erec-

tion. My scrotum was created from the former labial tissue. I was now very happy with the appearance of my genitalia, and I became much more interested in exploring and pleasuring myself. At last my genitals reflected my identity. The entire shaft of my penis is now sensitive to stroking, and my scrotal sack, filled with testicular prostheses (two silicone balls), is responsive to gentle kneading. I spend more time now massaging and pulling on my penis, feeling it get thick and hard, savoring the sensation of arousal for as long as I can make it last before I am compelled to orgasm.

I can come by stroking the shaft rapidly, slamming my fist into the base with the down stroke and pulling on the corona with the upstroke. The motion must be very quick if the goal is orgasm. I can also come using a vibrator placed alongside the shaft, or underneath it. But the easiest way for me to masturbate to orgasm is much like the way I did it before: brushing the flat of my hand very quickly back and forth across the tip of the erect penis. Now this motion is accompanied by the fantasy of my girlfriend sucking my erection, then flicking her tongue back and forth across the tip. I never liked oral sex until I could look down and see that my genitals were forward, extending, reaching out, erect and full, expressive of the way I feel about myself and about sex. Now, that's pleasure.

When I had a female body, masturbation felt secretive, illicit, mechanical, just a way to release sexual tension. Now that I have a male body, masturbation feels like an appreciation of myself. My increased sex drive probably originates with the testosterone I take, monitored to maintain a serum level in the normal range for a man my age. Like anyone else's, my body is not perfect, but my body is one with my psyche. Masturbation is an acknowledgement that this body is the right place for me to be.

Winning

Jolie Graham

He lays the cards out, eight at a time, in rows. Some are face-up on the table, some face-down. There are several cards left over which he holds in his hand, in reserve. This is a new version of solitaire. He loves it. "You see," he tells me, "this is set up in such a way that you can never win." He is very clever, I think.

The game he shows me moves swiftly and easily. He plays his cards well. But it is in the nature of the game he's chosen that it would end abruptly in stalemate. The jack of jerks routinely blocks the queen of hearts. When he lies on top of a queen of another suit, the jack of hearts with his half-smile can never look me directly in the eye. There is nothing I can do but play his version of solitaire and lose.

Later, alone, I pick up the deck of cards and begin laying them out like he showed me. I feel like a fortune-teller as I study the cards. "You have to be able to see ahead six or seven moves. It's like a chain of events," he had said.

Days later when he calls I tell him I have changed the rules. The lay-out he used was incomplete. I lay out all the cards in my hand. The columns and rows come out even. There are no cards held in reserve. Better still, I have discovered that with these changes it is possible to win.

I love the feel of the deck in my hands. Even though it's

the middle of the day, I've decided to take off all my clothes. It's always better that way. All the cards are in my hands. I can now play them however I want.

Kneeling on the floor in the living room, I shuffle the deck expertly, like a magician preparing for a conjuring trick. I have become very good at this sort of sleight of hand. For my first trick, I unhook my bra, pulling the straps over each arm, then removing it from beneath the shirt with a flourish. The dark areolas around my nipples are now clearly visible through the thin white cotton shirt. The fabric caresses my nipples as I lean back and forth, moving the cards. The game has begun.

As I rub both my hands over my breasts, I close my eyes then squeeze both nipples simultaneously. These are someone else's hands. Someone's hands are ravishing my body, his fingers sliding into the wide legs of my shorts. Leaning forward on my knees, my breasts above the cards, I consider my options while a hand explores beneath the shirt. Then the shirt is flung aside and instantly I feel cooler and more free.

I am crouched on all fours with my shorts pulled down over my ass; my fingers follow the cleft between my cheeks, creeping down towards the source of heat between my legs. Brushing my fingertips lightly over my ass cheeks I visualize curly brown pubic hair rubbing against me, the soft skin of a hot penis against the small of my back.

My mouth forms an involuntary O around his imaginary cock. Falling sideways on the carpet, I kick free of my shorts. As I roll naked on the floor, thrusting my fingers in as deeply as they will go, the king of hearts tries to suckle my sweaty breast. My hand gently kneads first one breast around the nipple, then the other. Oh, if only I could duplicate the sensation of sucking. That long thrill that threads through my body when a wet mouth encompasses a nipple tight with excitement is a sensation for which it's

almost worth having a man. But today I'd rather win.

My left hand pushes through my pubic hair until my middle finger finds my clit, just barely touching it, like the warm tip of a penis. Light but insistent pressure raises a cry for more. A hot flush sweeps over my body: I am hungry for fire. The desire to push onto that cock in my mind's eye is too great. I rock back and forth feeling the width of my fingers like some thick cock sliding between my legs, wet from my own juices. I am fucking it, sucking it, still wanting it.

I'm lying on my back beside the cards, legs spread, knees bent, hips pushing relentlessly onto his penis. Pushing harder. Deeper. I grind my pelvis against my own arms, both hands probing between my legs. The air reeks of sex. My body tightens. I want it so bad I almost cry.

Yes! Pushing with a deliberate rhythm onto him, I am coming, coming so fast that I can feel each successive wave of pleasure overtake the preceding one. My hands are clenched tight between my legs as if trying to keep all this joy from slipping away between my fingers. I can see his strong lean body and feel his swollen cock deep inside me. I can see six moves ahead and know that I have won.

Stigmata

Thomas Roche

The subject of masturbation seems to upset most people as few other things do. So is it any surprise that I thought my adolescent whack-off sessions were the reason I couldn't get a date? That people could somehow detect the scarlet "M" on my palm—Masturbator? In my scientific but mystically inclined mind, I posited that sexual energy was discharged, dissipated, dissolved, by masturbation, so that others wouldn't find me sexually attractive. But the underlying myth of this pseudoreligious belief was that I was branded, marked as a heretic. It was this fear that people would know that caused me to hide my stolen porn magazines or copies of *The Sensuous Woman* or *For Yourself,* secret away the erotic stories I wrote, and, later in my teens, put the TV on mute when I watched pilfered videotapes. My Catholic instincts still told me the psychosexual energies would give me some sort of stigmata—if not on my palm, then on my pillow, my jeans—maybe on my forehead.

Turned out it wasn't a scarlet "M" at all, nor was it ejaculatory stigmata, or a metaphysical bell hanging around my neck making telltale slapping sounds. I was just too weird for most people; this later gave me what I modestly consider to be some insight into my own and others' sexuality, so I guess it was all a blessing in disguise. But I

still take great pains to hide masturbation, if for somewhat different reasons.

In my adolescence, masturbation offered an absolute sort of privacy that was very hard to come by. It was the greatest, most obscene secret I could possibly have.

When I "do it" nowadays, I close the curtains, check to make sure no one's in the hall outside, double lock the front door, turn the music on loud, put the TV on mute, get ready to hide the magazines, and feel a curious tingling terror in the pit of my stomach.

It's not because I'm afraid anyone will find out I'm stigmatized with the scarlet palm across my crotch—truly, I wouldn't give a rat's ass if they did, or why would I contribute to an anthology such as this? I do all these things because that feeling of absolute privacy, of the anonymity of the closet, of doing something truly Evil and Nasty that nobody'd better find out about, is a delicious something that is rather hard to duplicate in my adult life where I'm confronted on a daily basis with a world full of civil rights violations, domestic violence, homelessness, nuclear weapons, industrial pollution, and about a million other things. Evil and Nasty are relative terms, hard to duplicate in the post-adolescent mind. But the sensation of doing something "evil" is exactly what makes this reviled act so exciting. If it wasn't evil and sinful, or if I wasn't able to convince myself that it was evil and sinful, it wouldn't be nearly as much fun.

Perhaps these stigmata, the twin scarlet "M's" on my palms, are really signs of holiness and devotion. But I prefer to think of them as symbols of sin and evil. It's more interesting that way, and anyhow, I was never inclined toward holiness.

So I pull the curtains, double lock the door...and "do it."

Tight Jeans

Jill Nagle

I love watching women in tight jeans—watching them sit, stand, squirm. I marvel at the conspiracy of silence (or is it forced ignorance?) that keeps us from visibly reacting to the erotic havoc the devilish denim wreaks with our sensitive flesh, playfully clutching and releasing our innocent vulvas.

We sit, lean, stand, and walk about our lives, discussing anything but the garment that happens to be fucking us at the moment. The perfect secret.

As a teenager, I experimented at length with finding *just* the right angle at which I could rock ever so slightly in a flexible office chair so that the denim would squeeze my mound in *just* the right way, until I came generously, pulled from front to back, side to side, waist held tight, ass grasped hard, clit under wraps and wriggling. The perfect toy.

I also discovered I could come quickly lying on my stomach in tight jeans and pressing upward with my arms from the floor—a move I learned in an aerobics class. In these classes, I had writhed and obsessed over whether the other women were getting as hot as I was, neon thongs wedged firmly in their cracks, squeezing their cunts against their torsos. I had fantasies of being an aerobics teacher and making roomfuls of women do these little fuck-me pushups until they came in unison, having no idea what I

was up to. The perfect crime.

Yes, hmmmm. Tight jeans. Maybe that's why I was in a constant state of arousal throughout my adolescence.

On the way home from the 1993 March on Washington, I boarded a half-empty bus headed to Philadelphia. Underneath my tight jeans was a black thong I had been careful to yank up my ass just so, to tease and agonize myself during this public day. In the semi-private confines of the bus seat I occupied alone, under the blanket, my hands began to wander. I found the thick knot of fabric that rested just below my clit, just where I like it. I scratched the fabric hard, creating vibrations throughout my groin.

I grasped the arm of the bus seat, and began to move rhythmically against my other hand. Sitting directly across from me was Yvette, the gorgeous waitress from the Cool Cat Cafe, the one with the diamond nestled just above her left nostril. Did she know? Could she see me, hear me? Slowly and with some difficulty, I unbuttoned the top button of my fly, wrestled my hand into my pants and up into my hot hole. My pussy eagerly sucked up my fingers, the heel of my hand embraced my swollen mound. There! I found the position that exponentially increased my pleasure. My whole body relaxed then surged forward. I knew now I was going for broke. I fucked myself to the knowledge that nothing in the world would interfere, nothing mattered more than my pleasure.

The more I fucked against my strait-jacketed hand, the more engorged my pussy walls and lips became, the more I lost consciousness to my body's delicious, insistent rhythms. In my cunt-mind's pussy-eye, Yvette was now the denim holding my hips fast in that quintessential embrace, allowing my fingers barely enough motion to move in my hungry cunt.

My body pressed and lobbied for just one iota increase of depth, of pressure, of speed. The steel-strong center seam

of the jeans (and my own anatomy) prevented even my forceful, determined hand from giving my cunt exactly what I needed. The hard knot of fabric where the seams met pressed painfully into the thin bones above my knuckles. I longed to soothe my tortured hand, but I couldn't stop fucking my pussy!

Don't you dare stop, my pussy demanded, calling from that small gap between deep inside my cunt and the ends of my fingers. I pressed on, driven and urgent, to fill the space between what I craved and what I was getting, coming toward it pressing, begging God and the Universe again and again.

God was that seam up my ass.

Yvette was the garment's squeezing, teasing promise. I looked across the aisle toward her. Her diamond shone above her blushing wet lips. As her eyes met mine, I shut my lids feigning sleep. My pussy clamped down again. My hand, martyr-like, bore the excruciating pressure, folding in prayer again and again.

God and Yvette were in cahoots. They were winking at each other as they placed that tension, that carrot in front of my nose, so close I could almost taste it. I imagined Yvette's voice in my ear, "You want it, don't you. Show me. Show me how bad you want it." I moaned softly, falling further down into the awkward seat, fucking like mad with my half-dead hand to keep the pace my pussy craved, trying not to hump too fast nor moan too loud. With the greatest of restraint, I pressed and bucked for more.

Unrequited desire wrapped around us tighter and tighter, winding the three of us together like a thick braid, God, Yvette, and me, three peas caught in a throbbing pod, three waists laced tight in a hot corset. My hand muscles practically collapsed as I came, filtering a scream into a long, hoarse sigh, pussy clenching again and again.

I opened my eyes, barely, and looked across the aisle.

Yvette immediately turned to gaze out the window. A little too quickly, I thought. Oh dear Jesus God. She must have known. Holy shit. I wanted to bite her neck, to pull her warm, winding body on top of mine while I recovered.

Tight jeans slightly stretched and loosened, I removed my now canonized hand, gently rubbed the stigmata, and sighed again, this time toward sleep.

I didn't dare open my eyes to look at Yvette.

Yes, I thought as I drifted off, yes. Tight jeans. Perfect secret, perfect toy, perfect crime.

Summer Camp

Emile Zarkoff

BB pulled his swimming trunks down to the top of his thighs and lifted out his large, semi-turgid cock. Mickey and I, sitting at either end of the canoe, watched in silent awe. Here, as the hot summer sun reflected off the smoothness of Hoover Memorial Reservoir, BB was going to show us how to do it. As we had just turned thirteen, our pumps were primed, but we didn't quite have the hang of it.

BB, Big Bear, was a mature fourteen years old, and more than pleased to be our mentor. He was almost six feet tall and beefy. He sported longish, thick silky black hair, that you probably could have wrung a tube of Brylcreem out of. He had a brashness born of his brute intelligence, size and advanced age. He knew how to jerk off and we didn't.

"Aw, go jerk off," BB would taunt.

"Why don't you, fart face," we would rejoin.

"You don't know even how, do you?" he sneered.

"Do too, faggot," we threw after him, of course not knowing what a faggot was, and certainly not ruffling a hair on his greasy head. I suppose if I met BB at the baths today, I wouldn't recognize him.

Mickey was in the bow and I was in the stern. We paddled BB around the lake like galley slaves of the young

Darius. As we stroked, he slowly, rhythmically, worked his hand up and down his cock.

Eventually an opaque, white, sticky, goo burbled up out of his grinning little slit. BB exhaled with a quiet rush. Is that all there is, I wondered.

"That feels sooooo good," he sighed.

If BB could do it, I figured, why couldn't I? That afternoon, I went back into the storage room in our cabin, feeling fairly safe since no one was there, and not particularly worried about being "caught." Among the shelves of freshly laundered towels and sheets, I pulled it out and got hard. I was working away at it when another kid walked in and said "Whatcha doin', trying to jack off?" That shut me down for a while.

I'm not sure when I made my next attempt, or when I was successful, probably not until I got home to the privacy of my own room. It was a stultifying Indian Summer, replete with the kind of muggy hot evenings the Midwest does so well. I kept a sweat-drenched sheet pulled over me just in case I was caught in the act. During those first furtive weeks of experimentation, my mother did walk in on me one night. The tent the sheet made with my rigid cock and body didn't begin to disguise my nasty handiwork. "Oh, ex-*cuse* me," she said. Her disapproval hung in the air for weeks like the stench of rotting fish.

At first all I did was form my right hand into a tube and run it up and down my cock. The only thing I varied was the speed. It took me a while to learn that Vaseline would prevent the chafing soreness my unlubricated hand was causing my cock. It took longer for me to get that I could grip the skin of my cock's shaft just below the head and run it up and down. By the time I was seventeen, I was learning to caress myself, play with my balls, and gingerly explore my asshole. It has taken me years to incorporate pornography, fantasies, toys, intentional breathing and varied

positions into my solo sex life. Happily I continue to encounter new ideas and techniques as I orgasm and ejaculate through middle age.

Vacation

Marie Hunter

I have always been attracted to Maine; even as a child I had been influenced strongly by the water. Born a Scorpio, I have only two real loves: water and sexual healing, or orgasm as some like to call it. Having the opportunity to be alone at my sister's summer home in Biddeford Pool provided me the unique opportunity to enjoy both.

Anxiously, I turned the key in the lock. My anticipation was about to be released just like the dead bolt lock. My pussy had been aching for hours. Between the vibration of the plane's jet engines and the rough ride in the back seat of the big yellow taxi that brought me here, I was ready to explode.

The summer housekeeper had already been here. There was fresh lemonade and a beautiful garden salad prepared for my dinner, along with a boneless chicken breast marinating in Italian dressing topped with plastic wrap and a 4" x 5" card greeting me and instructing me how to use the outdoor grill. Chloe, the housekeeper, knowing my distaste for seafood, had done her best to shop for me in the seafood capital of America.

Finishing my meal and rinsing off the dishes, I hurried upstairs to the master bedroom suite and found fresh white linens on the bed and a small box of Godiva chocolates that

Chloe had placed there for me. As I began to fill the oversized Roman bathtub with hot water, I rushed to my luggage to take out the brown bottle of "sensuality oil" I had purchased in Sedona, Arizona. I had asked a psychic if there was anything I could use to increase my sexual awareness and she had crafted the oil. I've never been the type to drink alcohol or to take drugs. But the scent of these oils was intoxicating.

The water in the tub was so warm that my feet and ankles stung. Slowly, I lowered my body into the warm, fragrant water. When I got deep enough into the water that my pussy and ass were submerged, I began to move in and out of the water, as if I were fucking it. Every time my body rose the water would cascade over my labia, past my clit. As I entered the water again, it separated the cheeks of my ass and caused a delightful pressure on my anus. Moving gracefully at first, I quickly progressed to bouncing in and out of the water like an animal. Hearing the water slap against my ass excited me tremendously. I could feel my clit swell with pleasure. I started to feel dizzy. I needed to come. I slid down to the very end of the tub, rested my upper body on my elbows, pressed my ass against the end of the tub wall, and spread my legs up and over the edge of the tub on either side of the faucet. I turned on the warm water and positioned myself so that the water would actually fuck me. As the water began to fill my vagina, my muscle contractions forced it back out in gushes. I neared orgasm, but wasn't ready yet. I rolled over, my hands supporting my body, and put my ass against the faucet. I rubbed my anus on the corner of the faucet, as water ran down over my clit. I began to finger my clit. Faster and faster I rubbed my clit, harder and harder I rubbed my anus on the faucet, the water splashing on my breasts. Orgasm came in strong peaceful waves over my body. Needing rest, I pulled myself out of the tub, wrapped a large Turkish towel around me

and collapsed onto the king-sized bed.

I awoke to the sound of the ocean crashing against the breakwater. It was as if the ocean was waking me so that it could have a turn to make love to me. Still naked from my bath, I opened the nine foot sliding doors and walked out onto the oversized sun deck. I lay on the large white *chaise longue.* The towel that was once wrapped around me now draped the lounge chair, leaving me naked before the rising sun. The sun felt hot on my nipples and labia, yet my arms and legs were chilled by the cool morning breeze. I spread my legs further by placing each onto a different piece of railing, my pussy and my breasts bare now to the ocean and perhaps to any passers-by that might be on the beach so early. Gently I pulled the towel up between my ass cheeks, then glided it slowly over my clit. My hips began to groove with delight causing my clit to press harder against the towel. With one hand I grasped my breast, my fingers taking hold of the nipple, while the other hand maneuvered the towel rising from between my thighs. As the end of the towel neared my ass, I grasped the free end of the towel with my other hand. Standing now I began to pull it back and forth, taking it from my asshole to my clit. My pussy had become so wet that the towel was becoming damp. Being so close to orgasm but still wanting more, I tied one end of the large towel to the top of the deck railing and grasped the free end with both hands. I rode the towel between my thighs as if it were a horse. My back facing the sun began to burn as did my pussy from the friction, I had to stop.

Stopping short of an orgasm leaves me with an animal instinct. I rushed back into the house in a frantic search for some object I could use to finish the job, but found nothing. I ran down the steps to the kitchen to continue my search for gratification. The refrigerator was full of gorgeous ideas and combinations. I took a handful of the grapes and

inserted them one by one into my vagina. The cold hard grapes felt heavenly. I began to insert the entire cluster. Standing before the wide-open refrigerator door I squeezed my pussy walls tight against the grapes. Then I reached forward and grasped the small yellow summer squash in the shape of a light bulb. I took my lovely little find over to the sink and washed it with hot soapy water while bearing down on the grapes in my twat. As I inserted the small end of the squash into my ass, my legs began to weaken from the excitement, so I crawled onto the counter and sat firmly on the yellow squash. Delightfully, two or three glorious inches went inside me. The grapes began to burst and gush out of my vagina due to the extra fullness now inside my ass. I put my feet into the deep compartment of the sink and slid my ass forward so my pussy was hanging over the edge of the basin. I reached forward to grab the sprayer, turned the water on and used the sprayer to beat and pulsate the water against my clit. As I squatted in the basin the grapes came completely out of my vagina, my ass clamped tight to the squash, and I began to fuck the sprayer. Playing with the water temperature, I took turns spraying hot and cold water against my clit. I began to come, orgasmic contractions pouring over me from head to toe.

Climbing down from the sink, I released the squash from my ass and threw it in the trash compactor. I used the sprayer to rinse away the remnants of fruit. Just as I finished wiping down the counter, Chloe opened the door to the kitchen. As I ran up the stairway, she chuckled, seeing that I was naked, and complimented me on how well I had cleaned up after my breakfast. "If only your sister and her husband would do the same."

"You're right Chloe! I do things in this house that my sister would never dream of," I replied, giggling to myself this time.

What Every Boy Knows

Antler

Every boy knows what it's like
 when he's really alone,
When it's safe to jack off with a passion,
When it's safe to take off his clothes
 and prance around,
And parade his lubricating cock
 before every mirror in the house,
Safe to cry out and talk dirty
 while jerking it,
Really scream, "I'm coming!"
 when he comes,
Really stand on his head
 and jack off in his face
 if he wants,
Yes, every boy knows
 when it's safe.

At the country picnic the 12-year-old boy
 wanders off by himself into the woods,
 he knows the perfect spot.
On his study-hall break in the library
 the 13-year-old stops in the empty john,
 just enough time for a quickie.
The 14-year-old boyscout waits till he's sure
 everyone in the tent is sleeping,

quietly, slowly he plays with his dream.
The 15-year-old runs home from school,
 halfway he's already hard,
His heart is pounding
 when he opens the front door,
He knows he's got a full hour
 before his sister or parents return,
Enough time to give himself
 a real workout in the bathtub.
The 16-year-old wakes up in the snowy night,
 with a flashlight he watches himself
 magically masturbate under the comforter.
The 17-year-old puts *Leaves of Grass* aside,
 leans back on the chair with his feet on the wall
 in the basement where he studies,
He likes poetry, but right now
 he needs a good hand job
 before he can continue....
No one can see me now,
 the boy chuckles to himself,
And I'm not fool enough anymore to think God
 is watching me horrified
 and will sentence me to hell.
If God doesn't love to watch boys jack off
 as much as boys love to watch themselves jack off
 he does not exist.
The 18-year-old boy licks his lips
 as he jacks off in the hayloft,
If anyone saw me they'd think I was nuts,
 he thinks as he squirms and groans,
His devilish lasciviousness to make love to himself
 makes the monkeys at the zoo seem prudes,
There's no posture, no expression on his face,
 no possible method of touch he won't try
 to make it feel more Wow.
The voluptuous 19-year-old knows

he's got the whole beach to himself today,
He basks naked in the sun,
then floating on the lake
gives himself the best handjob of his life.
The 20-year-old mountain climber still digs the thrill
of doing it on top of a mountain alone,
He never tells anyone, it's a secret
he keeps to himself,
He still smiles remembering the first time
he jacked off from a cliff,
Ecstatic boyhood semen spurting and spurting
tumbling thousands of feet
into the wild valley below....

The Missing Eighteen Minutes

Annie Sprinkle

It was one of those days. Being President of the United States was not always easy. The job produced a lot of stress and frustration, to which Richard M. Nixon was not immune, especially when he had to organize a Cover-Up.

He had a few minutes between appointments. The urge struck with full force. Dick tippy-toed over to the door of his Oval Office and instructed Rosemary and his Secret Service agents not to disturb him. He settled into his big, over-stuffed brown leather chair, sighed deeply, and turned his attentions away from work and towards his body, his breath and his groin.

Although he'd already had sex with Pat that month, he wasn't fully satisfied. Had he not been in the public eye, he would have gone to one of those fancy gentle-men's clubs and simply paid for what he *really* wanted, but this was another one of those little sacrifices he had to make for his country.

Even though he was always very uncomfortable with his sexual desires, he could not resist freeing his small, shy, semi-erect penis from behind his pants zipper. He proceeded to pet, rub, squeeze and stretch it. Often he would ejaculate in less than a minute, but this time he would try to make the good feeling last a little bit longer. It

was the most pleasure he'd felt in ages. His breath quickened to a light pant. A small moan escaped his throat. Conscious that all conversations in the Oval Office were automatically recorded, he was careful not to make any more sounds, but it was so difficult.

In his mind's eye he reviewed his favorite erotic image. It was always the same—a big, beautiful, dark-skinned Amazon with an enormous ass and a slippery, meaty, tasty vulva with massive amounts of curly, black pubic hair who straddles and smothers his tiny face. He is pinned helplessly to the floor. Her clitoris throbs and grows to enormous proportions, and fills his mouth. He cannot breathe or move and he must submit to her demands to lick, suck, and drink her.

Dick opened his eyes slightly to glance at his watch. Haldemann and the others would arrive any minute. He plucked a few sheets of Kleenex from the dispenser and prepared to ejaculate into them, conscious of not wanting to soil any of the important documents on his desk. The sexual feelings built to a peak, and, as he released them, he could not contain the sound of what was the best orgasm he'd ever had.

A wave of guilt and disgust rushed over him. His hands shaking, his heart pounding, and his face flushed, he frantically tried to compose himself. He wondered if the invisible microphones could have picked up his heavy breathing or the two grunts he accidentally made, but he doubted that they could. Besides, no one would ever listen to those tapes anyway.

Nice Girls Might

Karen Taylor

When I awoke, my lover had already left, leaving a note explaining an early meeting. I was understanding, but frustrated. Every morning for the last three weeks, ever since we had met, in fact, we had awakened by making love. Never had I been given so much sexual pleasure.

Enjoying sex had been inconceivable to me before this relationship. My mother's "birds and the bees" talk had been filled with concepts of loyalty and duty and empty of any physical description, except for a dark warning that "only sluts and whores moved when men "did their business," and sometimes did even nastier things that nice girls should never be expected to try or do.

When my lover suggested I masturbate for my own enjoyment, I nearly fainted with shame. I had never put my hands there, and it was only with difficulty that I had allowed anyone else to do so. One night, though, I placed my hand over my lover's, as fingers caressed me between my legs. The immediate intensity made me come harder than I ever had before.

Shortly after that, my lover gave me a gift—a dildo—to use in private moments. The idea of penetrating my own body was frightening, but by this point in the relationship my imagination was growing more creative, and I would

sometimes imagine thrusting the silicone cock in and out of my body when my lover asked me to touch myself. Now, I kept the dildo under my pillow, using its proximity to tease myself to higher planes of excitement. God, I was horny. But my arousal only served to remind me that I was alone.

My frustration grew. If I weren't alone, I could indicate my need, and be given pleasurable release. Now I was alone in bed, helpless, bound by my early training and shame. But perhaps I could fool my conscience.

Beside our bed, next to the condoms, was a box of latex gloves. I held a job that resulted in small cuts and abrasions on hands so I insisted on safe sex practices. I pulled a glove on. It was smooth and firm, enveloping my hand with an even tension. I tried stroking my thigh. The glove reduced my hand's sensitivity just enough so that I could imagine it was my lover's touch. Almost. I closed my eyes. Better. I finally took a pillow out of its case, and pulled the case over my head. The cotton pressed gently across my face, but didn't impair my breathing—which had grown faster. Now blindfolded, unable to see my hand betraying my body, I lay back against the pillows, and began to experiment.

I imagined whispers in my ear, promising me pleasure. My nipples hardened, and the gloved hand reached down between my legs. A gloved hand, my lover's hand, touching my clit, rubbing itself against my cunt to lubricate the fingers down to the knuckle, sliding back across my cunt lips and clit. My back arched in response, nipples pointing toward the ceiling. I imagined my lover's smile and low laugh of pleasure. My nipples ached to be touched.

I groped blindly on the night stand next to the bed, and found the newest toy with which I had been teased: two tiny clamps, joined by a chain. The clamps pinched my nipples, and I had gasped when they bit into my flesh. The pinching filled my cunt with juice, and I remembered thrusting my hips pleadingly when the clamps had been settled in place.

I pressed the first clamp onto one of my erect nipples. As the flood of pain rushed through me, I brought forth an image of my lover, pressing tight fingers around my nipples. I pretended to hear "I want to lick this one," murmured in my ear, and deceived myself long enough to attach the other clamp. I sank back onto the bed with a heavy sigh that made the pillowcase float away from my face. The pain/pleasure of the clamps brought my lover's hands and face to my memory, the hands pinching my nipples, the face sinking toward my cunt. The gloved hand crept back to my swollen clit and I heard myself moan, seeing my lover's face bury itself in my cunt in the darkness behind the pillowcase and my closed eyes.

I created sounds in my head, growls and wet, smacking sounds of lips against my cunt. I moaned again, and came quickly, my back arching, nipples throbbing against the clamps. I pulled the gloved hand away from my clit, startled at the intensity, worried that one orgasm might not be enough. Breathing heavily, I lay in the darkness, feeling my need grow again. I knew I could not stop now. My lover does not leave me only half-satisfied, and I needed to keep deceiving myself. Otherwise, the small voice in the back of my head, the one whispering "slut," would grow louder, and I would be filled with shame.

I reached under my pillow, my hands shaking, concentrating hard on the image of my lover. Subtly, so as not to disturb the image, I put the chain of the nipple clamps in my mouth to tug gently on the chain, mimicking the feel of my lover's hands on my breasts, pinching my nipples, tickling them with kisses and licks. The pillowcase was getting stuffy, and I pretended it was due to the weight of a body on top of me. I moved the gloved hand back between my legs, parting my cunt lips, and imagined my lover's voice, husky and low in my ear, talking of love and pleasure.

I let my head fall back, the chain in my mouth tugging

my nipples harder as I pressed the dildo into my cunt.

My cunt was so wet that I slid the dildo in easily, pressing only the head in, pulling it nearly out again, then sliding it in just a little farther. I was writhing pleasurably; my nipples, held captive by the clamps, pulled this way and that as I moved. My face was warm in the pillowcase. I thought of noisy breathing and murmured words, describing in intimate detail the sensations about to overwhelm me. I heard myself grunting, the gloved hand on my clit, the cock thrusting deeper into my cunt. I felt my lover everywhere on me, mouth simultaneously biting each nipple, gloved hand flicking my clit into frenzy, cock pumping in and out. I moaned, my body moving rhythmically under the image, hearing my lover urge me to greater and greater heights of ecstasy.

I howled in orgasm, fucking myself hard, jerking the clamps on my nipples to painful intensity.

The gloved hand remained on my clit, flicking it into yet another shuddering come, and I could feel the muscles of my cunt throbbing, the pressure rubbing my clit gently from within to provoke another ecstatic release. I was trembling helplessly, crying my lover's name over and over as the waves of orgasms rushed through me.

Weakly, I pulled the pillowcase off of my head, the cold air brushing my cheek like kisses. Keeping my eyes closed, I slid the dildo carefully out of my cunt and hid it back under my pillow. The glove was removed next, dropped by the side of the bed where, later, I could pretend it had been left from an earlier lovemaking session. Finally, I gently released my nipples, gasping as the blood rushing back into them provoked still another orgasm. Breathing hard, I waited again for my body to calm itself. But I could not yet open my eyes.

I created the image of my lover getting out of bed, going into the bathroom, getting dressed. I listened to the

footsteps on the stairs, heard the farewell called from the door. I waited until I heard a car pass the house, and told myself it was my lover going to work.

Only then could I open my eyes and get out of bed, my deception complete.

Queen

Dolphin Julia Trahan

y mother says I was born masturbating. As a
toddler I'd masturbate everywhere: the kitchen,
the living room, the park. My favorite story is
how, at the age of two, the evening of Neal
Armstrong's moon launch, I snuck champagne sips from
grown-ups' glasses and put on a show in front of the TV.

All mothers embarrass their children by describing
some adorable act or endearing habit. However, my mother
talks about my inherent sexual narcissism at dinner par-
ties. She tells my friends, says it in front of my sister's
boyfriend, and even told our real estate agent! I have asked
her to stop. She just giggles, her roly-poly body bouncing
merrily. I love her very much. I figure she can't help herself.
Actually I don't mind that she publicly talks of what is
usually considered a private act. She's making a political
statement.

At eight years old, and less exhibitionistic, I'd rock on
my bed at night dreaming elaborate fantasies. The usual
theme was that my favorite Knights and I, Queen of the
Girls, had been captured by renegade boys trying to con-
quer our majestic empire. We would be tied up, spread-
eagled, and fucked in every way, in every opening my mind
could imagine. All the boys wanted to fuck me 'cause I was
the Ruler of the Kid World, the fastest runner, the best

reader and the strongest wrestler. Only the boy Knights and Lords dared to fuck me, and I got fucked the most, the longest and the hardest. When I was satiated by enough sucking, fucking and Shakespearean drama, my band of merry Knights and I would easily overthrow the boys. Dancing all the way back to the girls' camp, we'd sing, eat and make love recklessly in glorious celebration of our divincly female victory. We never took prisoners. Who would want them?

I spent fantastic childhood nights this way. Sometimes, after school, I couldn't wait for dark. I'd sneak down to the basement and rock on my belly next to my sister's waterbed. Reaching behind me, I would stretch my lip-cheeks open and imagine someone from behind filling me, as I thrust hard into the carpet. When I came I was blue-eyed magic and possibilities. Until one day my sister interrupted, "What are you doing?" She was in junior high school and masturbation wasn't cool.

After that I took cold showers in the dark. I loved that moment when ice hit skin, my body spasming and squirming in painful euphoria. My heart tangoed. Leaving the world of the spinning, slightly moldy, metal shower stall I entered a world of brightly lit blackness. Under water no one lied and freedom was possible. This sacrament proved that I was rightfully Queen of the Girls. I was tough. I knew what mattered.

My grandmother, the Baptist, told my mom that people with disabilities—survivors of traumatic accidents and chronic pain—don't have sexualities. And said, "It's such a shame. She was such a pretty girl." But all sorts of people think about sexuality. Trust me they do. Take me for instance. Hit by a truck at age eleven. Bloody car seat. Bloody Julia. Mangled and mutilated by a truck, I lost a lot of things: 20/20 vision, the use of my left side and the ability to speak or swallow. Even lost my life and rose from the

dead, just like Jesus Christ. But the good ole, ever flowing life juice, erotic sexuality never left me for a minute.

Being born masturbating saved me. Sometimes the pain from crushed bones was too much. Orgasmic energy made my body bearable, waves of electricity washing and soothing my overstimulated burning nerves. The only certain thing was that if I didn't die from internal bleeding, time would pass painfully. Masturbating, I warded off panic and passed the time by shooting my psyche into worlds where I valiantly rode stallions on untouched ocean shores. Alone under the covers, fantasizing, I would slip my hand between my legs, my hurting body soon comfortable. There brave, beautiful women kissed my tears, whispering gratitude and admiration. Others spread long hair over my belly and made love to my wetness. Men, women and children left gifts outside my tent door in homage to my courage.

Unable to walk, I took refuge in my bedroom, and dreamt of fancy cocktail parties. My spread-eagled legs tied open in the doorway. My crotch convenient for amused cocktail goers to clean their shoes. Elegant tuxedoed gentlemen ground my clit with muddy wing-tips and their ladies, so fine, fucked my hole with five-inch heels. My clear come polished their pumps to an I-want-to-die-for-you gleam. I never screamed. And was rewarded by ghost cocks pummeling my throat, phantom long-nailed fingers ripping my ass. I shoved hate-filled fingers up my vagina until slow wanting tears slid me to a peaceful sleep.

Desire is battery acid in my veins. Each orgasm a hideous beauty that I must remember. Coming everyday. My sweat, cunt juice, tears and breathy moans are sacraments. With orgasm I lose my body. Discover it on the bed where I left it, in shameful puddles of shit, blood and vomit. I pick it up, wash it gently and say, "You are fragile. Celebrate your mortality." When I come I am the best kind

of Queen.

A longer version of this contribution appears as "Queen of the Girls" in *The Disability Studies Reader* (Routledge). It is also presented as a one-woman performance piece.

Eidetica

Roy Edroso

I suppose other people get hard and then want to masturbate. With me it's frequently the other way around. For instance.

I came home very late the other night. The neighborhood was silent and I was depressed. The first thing I saw when I came in was the message light blinking next to my phone. As I expected, the message was from the girlfriend. On the tape she sighed a lot and spoke in incomplete sentences. "Oh, God," she said at one point in a voice that sounded as if it were strained through a pillow. She finished by saying that I shouldn't bother to call back tonight, that she was sorry we fought, and that she loved me. I don't know if that was supposed to make me feel better, but it didn't.

I erased the message, got a beer and sat with it, watching some cheesy syndicated show on TV. A model-type girl wearing a sheer nightie with a scoop back was asking her boyfriend, shirtless and also a model-type, to tie her up. He seemed so confused by her request, his bull-like face scrunching up like a worried dog's, that it was funny. Finally he pushed her hands behind her back and pulled a white cord around them. The muscles of her back flexed. It reminded me of the girlfriend's back, the way it sloped and the way the shoulder blades strained under the flesh.

The scene faded out and I turned off the TV, went into

the bedroom and sat for a while in the middle of the bed, listening to the crickets and the distant audio wash of traffic on the highway. I looked to see if the white plastic bottle of cheap skin cream was still on my nightstand. It was and I was glad to have it there.

The problem with loneliness is that it puts you at the mercy of other people. Once you become reliant upon them, I thought, they have you beat.

I pulled off my clothes, all but my shorts, turned off the light and got under the covers. The air was getting cool; soon, I thought, I'll have to order some heating oil. I fidgeted and waited for sleep, but it was not coming soon enough and the darkness began to work on me.

At times like this, darkness actually scares me, like it did when I was a child. The night is so black and so vast. It's all right when it comes and takes you all at once, but it's torture when it waits, when it takes its time.

I shivered under the sheets. I put my hands over my crotch to warm it. Without thinking about it I slipped my fingertips under the waistband of my shorts. I started gently kneading my soft cock, as if it were a lump of clay, and it was sort of like that, a thing apart—I could barely feel it, but for the slightest tingle along the skin.

I thought about sex with the girlfriend but it just made me sad. I thought of the woman on the TV show but she reminded me of the girlfriend.

I picked through some of my favorite memories of sex with other women. I thought of a girlfriend who used to give me blowjobs as if they were a painful duty. I recalled her head between my thighs, the sorrowful arch of her eyebrows over her clenched-shut eyes. I thought of my hands reaching down her back, pressing against her shoulder blades until her eyes squeezed tighter and she shook her head and tried to say "no," causing her tongue to buck under the shaft and the head to throb in her throat.

I held that moment hard in my mind—stretched those few seconds out, replayed them, felt as if they could be everlasting—and my cock began to wake up. But when I reached for my goo and brought back a cold handful, the power of memory started to fade.

My mind then ran to a very fat woman I had taken home one night years ago. Normally, the thought wouldn't excite me, but I focused on her breasts, which were very large and pliant, with great brown rings around the stemlike nipples. I was drunk and gleeful and a little amazed at them, and really played with them, rubbed and pulled and pinched and kissed and licked them. Alone in my bed I could still feel them now, spongy, cooler than the rest of her body, separate somehow.

This memory melted into the memories of other breasts that I had touched and some I had just seen on the street: nice round ones snug against thin blouses, breasts like the prows of ships, breasts that sloped like bookstands against blockish chests. And I thought of asses that pulled up the back of otherwise loose-fitting dresses and asses packed into tight jeans, hoisted by the back pockets hard up against the pelvis with ass-fat spilling off to the sides, asses that drooped and asses that sprang at the touch and asses that fit, or seemed to, into the palms of my hands.

I thought of the feeling in my hands of the ass of one of my first girlfriends, the one who taught me to fuck. I remembered her on top of me, confident and exact, grinding slowly into me, urging me, "come on...come on..." as my hands, trembling with excitement, sculpted her alabaster cheeks.

I encouraged and squeezed my hardening cock. "Come on," I muttered. I concentrated just on my cock. I knew I could get it hard. I had done it before. I tried to remember....

And in trying to remember I did.

I was very young and touching with awe one of those

first miraculous erections that would come to me out of nowhere. During the day those erections were merely annoying, but when I was alone in my bed at night they fascinated me. I didn't know what they were exactly. But I liked how it felt when I touched myself; the skin was hot but flushed and when I rubbed my cock against my thighs a feeling seized me and shot from my crotch through my whole body. I remembered playing with my cock in the bath—I could smell the soap and hear the soft splash of the water echoing in the tub; I could feel the water sloshing all around me as I arched silently coming and see the slick of ejaculate floating on the water. I remembered how, when I rubbed, I felt as if I were carefully, gently scraping layers of skin from my hard pink cock like I was lathing it, in an ecstasy of creation, into something that would serve me throughout my life as a man. I had not needed to fantasize. No one else had to be in on it. The feeling, the blissful feeling, was enough. It surged in me and shot through me in exactly the same way I had once fantasized that love would. And now I knew if no one loved me, I would still be all right.

A long time before, in the deep sorrow after my father died, I had promised myself never to let such a feeling overtake me, no matter how hard it seemed to fight. But I could make an exception for this. I was alone with it. It was all mine.

My hands sank down against my thighs. They were greasy and the sheets stuck to them. My dick curled between my thighs, tender and warm and moist. Darkness seeped in from everywhere, filled my mouth and nose, smoothed my brow and saw me gently to sleep.

Warm Silk

Carol Queen

My skin feels like buttered silk after I come. I run my hands over my belly; my thighs are still pulsing and aching as if I'd run up several flights of stairs, and I swear I've never had anything so wonderful under my hands as this glowing expanse of my skin.

What I love about getting turned on when I'm alone is that it sneaks up on me. I run around all day, busy and maddened. I slump into a few stolen hours of solitude at day's end, too tired to return phone calls, much less think about watching sexy videos or opening dirty novels or pulling the Hitachi out from under the bed. Far too tired to think about sex.

Yet I've been thinking about sex all day.

Every bus shelter poster of k.d. lang or Roger Craig I drove past today. Every short skirt and every luscious set of buns in bike shorts. Every sparkly-eyed girl or guy I waited on in the store; every tattoo, pierced lip (or nose), pointy boot, fishnet-stockinged leg, leather jacket, every tight dress, every pair of jeans faded where the cock rests or rises, every hole in a pair of jeans, especially where the white warp-threads lattice and half-cover the skin underneath; every red-painted mouth, the darker the better, and scarlet-lacquered nail, especially short ones; every pair of

young lovers or old lovers or any sort in-between in any
gender combination, with extra points if the gender's indis-
tinguishable; every teenaged boy trying to hide his hard-on,
Catholic schoolgirl who's hiked up her skirt or put on lacy
tights, boy's ear pierced by one gold ring, black bra peeking.

And at home! Too tired to notice the pile of books and
magazines with contents devoted to sex, lingerie spilling
out of drawers like it's been trying to come alive, piles of
pearly-cunted seashells which I scatter around, all these
femmy, flowery curtains; four kinds of lube, an antique
Roseville dish full of condoms (four kinds of those too), and
a box of sex toys that'd get me busted in Texas (and lots
more in the closet); a set of steer horns, gleaming, pointed
and priapic, red candles and ostrich feathers and my old
white-enameled wrought iron bed with enough bars to tie
two or three people up to, not to mention the big mirror
situated next to it, all the scenes it's seen.

And all the pictures—of my lover (now and when he was
a little boy), of my ex-lover when she was a little girl,
holding the stuffed tiger she used to masturbate on, of my
adolescent friend who's not old enough to think about but I
do anyway; of a turn of the century dancehall girl with a big
snake, a young leatherman with a snake, Gustav Klimt's
"Water Serpents," two lovers twined around each other like
snakes; of Madonna, Marilyn Monroe, the Virgin Mary, and
angels with their wings mightily unfurled, and French
whores and antique lingerie and old pinup girls; women in
sailor suits who look like sisters but were probably lovers,
holding hands in 1919, sisters photographed by Imogen
Cunningham which I bought at the Art Museum gift shop
because their small breasts and curved bellies look just like
mine though the shutter snapped in 1920, the year my
mother was born; Betty Dodson's muscled couple fucking,
that people always think are both men (that's why I bought
it); and of course my Dad, debonair in his officer's clothes

and thin moustache who can be sexy now because he's dead, and anyway the photo's from fifteen years before I was born.

And somehow it still surprises me when I find in my fatigue that I can't sleep, that the pillow feels too hot on my cheek, that I toss and turn. What I love about this turn-on is how my body won't let me forget I've seen all those things today, a thousand sex-signifiers that my mind has stored and my flesh and blood remember.

So when I finally run my hands over my skin I find I am already releasing into little tension-orgasms, not real comes but little flurries of shaking at the relief of my touch, and if I keep this up I will drive myself crazy; the more I touch everywhere else, the more my pussy wants it. Sometimes this starts with me beginning to think about, no, just be aware of, my asshole, and before long my body is a writhing snake with my asshole its hungry mouth and nothing will satisfy me except to slide something in and fuck myself as slowly, at first, as I can stand, as hard and fast, then, as I can manage with my hands tense and trembling—but not tonight.

Tonight my clit is hard already and insistent. My clit wants it. My skin is prickly in a lush way; my body full of tension, the sex-tension so intertwined with the city-traffic-tension and the too-many-phone-calls-to-make-tension and I'm-on-deadline-but-I-can't-think-tension that I can't separate it, and all I can do is let it all work together.

I can reach my vibrator without turning on the lamp. Car headlights cut flickering beams across the wall. I raise my knees under the blanket, make a tent for the Hitachi, switch it on. At first buzz my heels dig into the sheets and the muscles in my arm pump like I'm weightlifting. Then I relax into the vibration, descending into the valley before I start to climb.

The vibrator is on my clit as a tease. I don't come that way; I want my cunt full, if not with cock and fingers then

with a zucchini or a dildo or my dad's old hairbrush handle. I used to fuck the strangest things before I discovered sex toys—protruding knobs on furniture, anything. I love the wave of crazy horniness that washes over me when I'm alone, separate from any love or lust I feel for a woman or a man, that makes me want to straddle bedposts. I love the frantic attempt to take the whole world into my cunt, a juicy itch that can't possibly be scratched from the outside.

Tonight I fish in my toybox—not moving the vibrator, which purrs mechanically on my clit—and pull out the first cunt-appropriate toy that comes to hand. Two ivory plastic balls, the size of ping-pong balls but heavier, attached by a cord. Slicked with a little lube and pressed against my labia, I disappear them with twin moans: "ohhh...ohhh." Hearing my own sounds is more exciting when I'm alone and sometimes, though not tonight, I talk the whole time, at once lewd show-off and *écouteuse*. Tonight I'm distracted by this tense and building wave of need.

I am so tense that tugging on the string is difficult, but each tug moves me palpably higher, whether it's rhythmic, as it is at first, or a wild and frenzied yanking. By the time I lose my rhythm it's too late. I am stretched out taut. The flexible neck of the Hitachi is bent nearly at right angles and its purring has changed to a labored, complaining whine because I'm pressing so hard. I hold the vibrator against my clit from the left, with my labia cushioning it. The nearness of orgasm brings my body up like a bow, the arc I learned about from Reich and my first girlfriend, the one who used to rub off on the stuffed tiger. It is an entirely different electric current from anything else I know. I feel in and out of my body all at the same time. In that second when my body arcs up at its tightest—and only then—I understand what *release* means.

It no longer has anything to do with tight jeans and pictures of Madonna. I'm not even human, and that's the

best release of all. I'm part of the electrical energy of the universe, part of natural law, one with the protons and electrons, one with satellites circling. It's the clear, breathless instant before my cunt starts pulsing stronger than my heart. It's the second I feel my voice get ready to howl. Tonight it's so strong I bellow like the stuck calf of the Goddess; my whole body spasms like my cunt—out of control, writhing and snapping, I feel like a necklace of pearls whose string has been cut.

The second time my orgasm's even stronger, and with the first squeeze of my cunt I gush scented sex brine all over the hand that holds the ivory balls' string; the balls come squirting out with the nectar, and somehow, somehow I manage to switch off the hot and throbbing Hitachi. I am flushed pink and panting.

Slowly I come back to myself, begin hearing the sound of cars again, notice the moving shadows again on my wall. My awareness comes back without the tension, like warm liquid filling a hot water bottle. I know it's been a big one because I feel the sweet muscle-soreness of working out. Best of all is my skin, wrapping me up, holding all the loose wet pearls inside, so alive to my stroking that I almost want to start over again, but no, I've had enough for tonight—I'll put myself to sleep stroking this warm, buttered silk.

This contribution will also appear in *The Ecstatic Moment: The Best of Libido* (New York: Delta, scheduled for August 1977 publication).

Memoirs of Masturbation

Rudi Kremer

As I approach sixty, I reflect upon nearly half a century of masturbation. The culture tells me there are hard lessons in front of me about my sexuality. But my culture's messages on sex have always been a bunch of hype. What my inner wisdom tells me is that in old age, as my body and physicality recede in importance, there is a whole new basketful of goodies around the bend, over the hill, unimaginable bliss.

I began playing with myself at an early age. My earliest consciousness of sexuality in my own body came from the deep vibrations of the streetcars and as a response to the purring of the family cat when I would hold it.

I was secretive about my bodily functions and the bathroom became a temple of privacy in which I could do what I wished, unsupervised and unobserved. I was fascinated with my own erection and spent many hours in the hot water of the bathtub, a preserve where my mother did not intrude except to lay fresh dry towels on the radiator to warm. I kept a covering of bubble bath on the water to keep secret what was doing. My cock—for which I had no name— became an island in a soapy sea and it was not too long before I learned to stroke and caress it, using the bubbly suds as a lubricant, watching it grow long and tall in my hands. For years I believed that this complex arrangement

of suds and hot water was an essential component of my pleasure.

It was with great surprise that in my pre-teens I had a series of what the government sex guidebook (that my parents kept inadequately hidden away) called "nocturnal emissions." These were dreams which culminated in my member dumping quantities of hot sticky fluid into my pajamas. I'd wake in a confused panic, wondering what to do with my spoiled pjs before mother could find out.

Soon I was jacking off at least once a day whenever I got the opportunity. There were jokes about masturbation among the schoolboys, but I never connected my own sacred personal practice with these crude and nasty references. Although I began having occasional sexual contact with others, my personal self pleasuring didn't change. I remember being obsessed with fear of getting caught and I was glad when my family moved to a house that had a stout lock on the bathroom door. Also, the wet dreams had taught me that it was possible to use my bed for personal sex play, catching the ejaculate in tissues which I flushed down the toilet.

In my teenage years, I added simple costuming and mirrors to my practice. I would roll up a pair of undershorts into a thong-like bikini and pose in the mirror as I pulled on the tight little garment that held my erection. This was a kind of foreplay. By the time I brought out the jar of Vaseline I was ready to go at it in earnest. I would glimpse my newly grown chest hair in the mirror for an added shot of pleasure. I did not really have a fantasy life connected with my private sex play, but I had a carry-over or link between my private and public life. I wore shirts to school which subtly revealed my chest hair.

Though I began to develop relationships and to achieve sexual fulfillment outside of my private practice, this only caused me to increase the frequency, duration and intensity

of my masturbation. And just as I did not have a fantasy life during my self sex, I would not ever masturbate when I was with a partner. Thus my two types of activity were equally important but separate. Images of shame and guilt from religion and culture never seemed to overtake me. But I was very careful not to get caught.

In my twenties I noticed that the soreness I experienced in developing greater physical strength had a sensual component. I would wake in the morning after a day of hard work and my aching muscles would make me more aware of my whole body. This was the beginning of a sexuality that was not just genitally focused. An important discovery, I thought. In the mirror I noticed greater muscle definition and this turned me on.

But I was becoming a workaholic who didn't allow much time for sex either with myself or others. My jacking off was done mostly in the shower as I prepared to leave the house. As my personal sexuality languished, so did my inner life and my connection with spirit and with creative endeavor.

It was not till I was in my thirties that I consciously developed an active fantasy life, giving myself sexual adventures. One of the things I did was to train myself to ride the wave of orgasms. Now my personal sex life became linked to my partner sex. My private practice began to give me both the restraint and the spontaneity that I needed in order to match energy with a partner. I did therapeutic work to get the inner permission I needed to go out and get my sexual needs met. During this time of change, my masturbation practice was an act of prayer, of grounding, an affirmation that I could get what I needed.

I found regular partners with whom I was sexually compatible. I developed intimacy with them. I began to let down my veil of secrecy. After all, these new people in my life were not my cold and restrictive parents. They were playmates!

As I developed an active outer sex life, my self pleasuring became more intense, more imaginative. I did role playing, became the nasty bad boy. I developed a collection of rags, leather, tight little shirts, revealing and perverse underwear, nipple clips, sex books, butt plugs, punk jewelry, and cock rings. I made collage and picture collections based on my sexual tastes, wrote porn and distributed it to friends and just about anyone else who was interested. I divorced and found myself a regular partner with whom I was compatible, a woman with whom I could link my sexual odyssey. Gradually the two of us became more intimate. It was a kind of gateway the day we were able to witness the other's private self-pleasuring.

A few years ago my mate found it necessary to spend most of a year on the East Coast. Were it not for my trusty left hand I would have been in a difficult position. I had no immediate recourse to a substitute lover during this time. Neither did I wish to become celibate. Thanks to my self-pleasuring, no problem. Masturbation in this context was an important activity helping to maintain my emotional and mental balance during a time when my partnered sex life was on hold. And it was—and will always be—much more than this. Self-pleasuring is as much a part of me as my life as a father, as a husband, as my friendships and hobbies. It is an essential and respected part of my life.

Beachin'

Marcy Sheiner

A h, San Francisco! Balmy weather, artsy cafes, sun-drenched or fog-shrouded beaches. I strolled along Baker Beach on a sparkling October day, congratulating myself on having left the rot and decay of the Great Northeast merely two short weeks ago for good. The Left Coast was my home now, the place where I'd stake my claim to fame and fortune, find my soul mate, learn to live a "laid back" California existence.

Looking back, I see that I was naive in many ways, not the least of which was my total lack of awareness that I'd just moved to Sex City, U.S.A. Oh, sure, I knew the place was a gay mecca where everyone could be themselves, and I looked forward to being out as a bisexual. But with all those gay boys cruising one another, I figured encounters with men would be few and far between.

Not even this thought could dampen my spirits as I made my way along the beach, toward the cliffs rising in the distance. Slowly it dawned on me that the further I walked, the less clothing people were wearing, until I found myself almost entirely surrounded by naked bodies. Vaguely I recalled hearing that this strip of sand was a nudist haven. Indeed, sunbathers bared all and naked volleyball teams cavorted. My eyes roved from one body to another, awed by the sight of asses and breasts and penises bobbing

unself-consciously in the breeze. A far cry from the bundled-up folks back East.

Though I knew I stood out in my print shorts and t-shirt, I couldn't imagine publicly baring my own flesh; never would I allow strangers to see my physical flaws in the harsh light of day. Oh yes, I definitely needed time to become acclimatized to this brave new world.

I meandered over to the cliffs, sat down on a craggy rock, and watched the waves rolling in, lost in thought. To my right was a small clearing sheltered by huge rocks lapped by the sea. Suddenly out of nowhere appeared a tall, thin man, naked but for a blue baseball cap and dark sunglasses. He was bearded, dark, good-looking. My eyes immediately fell to the place between his legs, where hung the longest, thickest cock I'd ever seen outside of porno films.

Briefly the stranger glanced up at me, then proceeded to wander around the clearing. I smiled inwardly, thinking he was just a guy on the make, parading his goods for my inspection. After strutting about for several minutes, he leaned against a rock and, to my astonishment, began fondling himself. Quickly I glanced around; a few people were scattered here and there, but no one else could see him. My first impulse was to run; the guy was obviously a pervert who, if encountered on a subway or dark street, would have scared me to death.

Still, I was mesmerized by the movement of his long thin fingers around his throbbing prick. So I watched. And he watched me watching. My cunt juiced up and my mind went wild; I imagined diving over the cliff and impaling myself on the handsome stranger's stiff prick.

Just then a teenage kid came bounding over the rocks. My flasher instantly ceased all activity. I considered leaving—but, much to my shame, I found that I couldn't. I desperately wanted to see more. Surreptitiously I glanced

around for more intruders, and when the coast was clear, cast a subtle nod in the stranger's direction.

He resumed his self-pleasuring, leaning back luxuriously, allowing the sun to dance across his hairy chest and moving hands. Slowly he stroked his dick up and down for my viewing pleasure. My mouth tingled with desire and lust, and I briefly considered running over and giving him the blowjob of his life. But for all I knew he really was a pervert, possibly even dangerous; maybe he had a gun hidden beneath his hat (remember, I was fresh off the streets of New York).

You know how some guys masturbate, desperate to come, jerking it so fast that their prick moves in a blur? Well, this guy wasn't "jerking off;" he was loving his dick and showing me how much he loved it. He took his sweet time, fondling and stroking, waving it teasingly in my direction. He let his prick stand straight up to its full glory while he squeezed his balls. The sun glinted in the drops of pearly cum forming on the smooth head. And I sat, impassively watching, pretending that nothing out of the ordinary was going on, while my cunt palpitated and my mouth salivated.

Finally my masturbator surrendered to nature in the fullest sense of the word, letting his milky fluid spurt into the briny sea. I allowed myself another moment to feast my eyes on his cock as it slowly went limp, then jumped off the rock and walked rapidly away, hotter than a furnace.

I must have been emitting animal smells, because every man on the beach turned to look at me as I passed. Any one of them could have thrown me down and fucked me on the spot, and I would have been grateful. As it was, I was going to have to find release on my own. But how to do that in public?

They say necessity is the mother of invention, and in this case it was surely true. It didn't take me long to figure

out how to masturbate surreptitiously—in fact, I taught myself something that day that I was to practice many, many times in the future. I gathered a small hard mound of sand in one spot underneath my blanket, then lay face down placing my cunt directly over the little sandhill. I put a book in front of my face and rubbed my pelvis up and down in infinitesimal movements, pressing my clit hard into the sand.

My eyes glazed over so the words on the page in front of me swam around meaninglessly. The sun beat down on my bare legs; the ocean lapped ceaselessly before me. People strolled all around me, and no one noticed anything unusual when my cunt convulsed and my whole body shuddered in orgasmic release.

As soon as my orgasm subsided I left the beach, my mind a whirlwind of confusion. I thought about friends who would have been appalled by the stranger's display and shocked by my acquiescence. So many of us have been frightened as little girls, hiding in some apartment stairwell while a "dirty old man" jerked off. Most of us have seen men whip it out on the subway or the street, in parked cars or movie theaters. These unwanted displays scare and disgust us—yet there I had sat, watching, even encouraging, a man to masturbate before me.

But, I reminded myself, I had been safe. I'd known the stranger could not touch me. Had I encountered him in a dark alley I would certainly have fled in terror—but this had not been a dark alley; this had been a sunny beach in San Francisco.

Many times since then I've returned to my beach in San Francisco, and though I have never again encountered my handsome stranger, I've enjoyed many delicious orgasms humping against the sand, unnoticed by other beach lovers.

Ready to Write Your Own?

Our printer told us that leaving a few blank pages here meant less handling on press. So we thought we'd invite you to write your own First Person account of your self-pleasuring.

— *The Staff of Down There Press*

About the Editor

Joani Blank worked as a sex therapist and sex educator starting in the early 1970s. She taught human sexuality at the community college level, led sexuality workshops for women, and was an active volunteer and trainer at San Francisco Sex Information.

In the spring of 1975 she started Down There Press with the publication of *The Playbook for Women About Sex*. Down There Press now publishes the work of other authors as well, and boasts a list of a dozen titles.

In 1977 Joani opened Good Vibrations to provide a retail outlet for her books, as well as a comfortable and non-threatening environment where women especially could learn about and buy sex toys and books. She also began to fill mail orders for the store's products, and in 1988 started The Sexuality Library, a mail order catalog of sexual self-awareness and enhancement books.

In 1992, Joani and her employees reorganized the company as a worker-owned cooperative. She is now recognized as Founder and Publisher Emerita, while continuing to promote the business and pursue her interests in cohousing and community economic development.

Joani is a graduate of Oberlin College and received her MPH (in Public Health Education) from the University of North Carolina at Chapel Hill.

Suggested Reading

CELEBRATE the Self. Newsletter for the male solo sex enthusiast, promoting "the goodness and sacredness of the body and its sexuality." (Factor Press, P.O. Box 8888, Mobile AL 36689) $19.95/year

Good Vibrations: The Complete Guide to Vibrators, Joani Blank. Everything you ever wanted to know about vibrators and couldn't imagine asking: where to buy one, how to use one. (Down There Press, revised 1989) $5.50

Great Vibrations. Joani Blank directs exhibitionist Carol Queen in masturbation techniques incorporating vibrators. (Blank Tapes, P.O. Box 8263, Emeryville CA 94608, 1995) $30.00

The Joy of Solo Sex, Dr. Harold Litten. A masturbation manual for men offering information and inspiration to enhance the experience of selflove. (Factor Press, P.O. Box 8888, Mobile AL 36689, 1992) $12.95

More Joy..., Dr. Harold Litten. (Factor Press, 1996) $12.95

Selfloving. Betty Dodson's video of her women's masturbation workshop. Dodson, Box 1933, Murray Hill Station, New York NY 10156, 1991) $39.95.

Sex for One: The Joy of Selfloving, Betty Dodson. An autobiography of one woman's adventures with electric orgasms. (Harmony/Crown, 1987, revised 1996) $14.00

Solitary Pleasures, Paula Bennett and Vernon Rosario, editors. (Routledge, 1996) $18.95

Many of these books are available from Good Vibrations, 1-800-289-8423.

To Order Down There Press/Yes Press Books:

_____ **First Person Sexual,** Joani Blank, editor $14.50

_____ **Exhibitionism for the Shy,** Carol Queen. "A sexual travel $12.50
guide" (_Libido_) to discovering your erotic inner persona
and building self-confidence.

_____ **Herotica®: A Collection of Women's Erotic Fiction,** _Susie_ $10.50
Bright, editor. Short stories that sizzle and satisfy.

_____ **Femalia,** _Joani Blank, editor._ Thirty-two stunning color $14.50
portraits of women's genitals by four photographers,
demystifying what is so often hidden.

_____ **The Playbook for Women About Sex,** _Joani Blank._ $4.50
Activities to enhance sexual self-awareness.

_____ **Anal Pleasure & Health,** _Jack Morin, Ph.D._ Comprehensive $16.50
guidelines for AIDS risk reduction and safe, healthy anal
sex for men, women and couples.

_____ **The Playbook for Men About Sex,** _Joani Blank._ $4.50
Exercises to promote a healthy sexual self-image.

_____ **Good Vibrations: The Complete Guide to Vibrators,** _Joani_ $5.50
Blank. "...explicit, entertaining....encouraging self-aware-
ness and pleasure." _Los Angeles Times_

_____ **Sex Information, May I Help You?,** _Isadora Alman._ $9.50
A witty romp through the volunteer training at a sex infor-
mation hotline, and an "excellent model on how to speak
directly about sex." _San Francisco Chronicle_

_____ **Erotic by Nature,** _David Steinberg, editor._ Luscious prose, $45.00
poetry and duotone photos of and by women and men
in an elegantly designed cloth edition.

Catalogs — free with purchase of any book, else send $2

_____ **Good Vibrations Mail Order.** Sex toys, massage oils, safe
sex supplies — and of course, vibrators!

_____ **The Sexuality Library.** Over 300 sexual self-help and en-
hancement books, videos, audiobooks and CD-ROMs.

Buy these books from your local bookstore, call toll-free at
1-800-289-8423, or use this coupon to order directly:

Down There Press, 938 Howard Street, San Francisco CA 94103

Include $4.00 shipping for the first book ordered and $1.00 for each
additional book. California residents please add sales tax. We ship UPS
whenever possible; please give us your street address.

Name _____

UPS Street Address _____

_____ ZIP _____